The Life of
L. S. LOWRY

Allen Andrews

The Life of
L. S. LOWRY
1887–1976

London
Jupiter Books (London), Ltd.
1977

First published in 1977 by
JUPITER BOOKS (LONDON) LIMITED
167 Hermitage Road, London N4 1LZ.

Copyright © Jupiter Books (London) Limited 1977

ISBN 0 904041 60 3

Composed in 12pt Monotype Bembo, Series 270,
and printed and bound in Great Britain
by R. J. Acford Limited, Chichester, Sussex,
using 115gsm Antique Laid paper supplied by
A. H. James and Company Limited, London.

For

JULIANA UHART
There are
nine and sixty ways
of constructing tribal lays
And every single one
of them is
right.

Contents

Illustrations

Acknowledgements

I HAVE HAD the utmost help in the making of this biography from Lowry's oldest friends and from the critics who ran alongside him for many laps: from all his civilised acquaintance, in fact, whose affection Lowry held during his lifetime and who want to see his reputation honoured by as accurate and just an account as may be possible. Since Lowry never habitually kept copies of his letters, the documentation in his life is meagre except for the official and periodical archives in the General Register Office and the British Museum and the Lowry-Carr correspondence in the Victoria and Albert. Much of Lowry's story is still in the oral tradition, in repeated reminiscences to his friends – where it is valuable to note the differences in the versions as well as their corroborations – and in a number of audio-tapes of Lowry, made by his friends, which I have been fortunate to hear. I am particularly indebted to the Reverend and Mrs Geoffrey S. Bennett; Mr and Mrs Monty Bloom; Mr James Fitton, R.A.; Mr Albert Hunstone; Mr Sidney Hutchison, Secretary to the Royal Academy; Miss Edith Le Breton; Mr Alick Leggat; Mr Mervyn Levy; Manchester Central Reference Library; Mr John Maxwell; Mr Edwin Mullins, who during preparation for the Retrospective Exhibition at the Tate Gallery in 1966 was very close to Lowry and recorded Lowry's current version of his career in the *Sunday Telegraph*, to which newspaper I give grateful acknowledgement for permission to refer to this; the Pall Mall Property Company Limited; Mr Philip Robertson; Mr Norman Satinoff; Mr Stanley Shaw, Curator of the City of Salford Art Gallery; the late Mr Leo

Solomon; and Mr Frank Whalley. The quotation by Mrs Carol Spiers on Page 102 was spoken to Michael Hickling of the *Sunday Telegraph* on 5 June 1976. I would also like to thank the *Guardian* and the *Manchester Evening News* for permission to quote material.

A. A.

The Life of
L. S. LOWRY

Chapter One

L. S. LOWRY once made a memorable comparison between accuracy and rightness: 'I saw the industrial scene, and I was affected by it. I tried to paint it. All the time I tried to paint the industrial scene as well as I could. It wasn't easy. I wanted to get a certain effect on the canvas. I couldn't describe it, but I knew when I'd got it. Well, a camera could have done the scene straight off. That was no use to me. I wanted to get an industrial scene and be satisfied with the picture.'

The biographer's biggest problem is to write a life which combines the best elements of accuracy and rightness. This is complicated in Lowry's case by the fact that the artist himself published a number of pastiches, each of which, though individual, presented an acceptable and fairly consistent self-portrait. But they were comparatively shallow and not fundamentally accurate. There was a timidity in his character which promoted deviousness, and he remained always a very private person. 'You could talk to him for an hour,' recalled a friend, 'but not know anything more about him if that was his choice.'

Lowry had a few close acquaintances whom he encouraged, separately, to believe that they shared – alone with himself – some of the secrets of his past. These confidants were selected from different areas of life so that in normal circumstances they were unlikely to meet each other. If later a possibility arose that tracks would join, Lowry engineered the contours of his daily life to put off the confrontation as long as possible, and in the meantime he doctored the relevant accounts of his history so that they

were in a decent state to marry when they met. Not every passage of the chronicle was individually tailored. Because he lived for eighty-eight years and was at once lonely and articulate, Lowry tended to be voluble when the occasion for speech did arise, and he shaped many of his anecdotes and self-deprecations into a classic form weathered by time and human reaction. Much of Lowry's past, as filtered through Lowry's lips, comes down as an oral tradition which is remembered in standard, often identical, phrases by many separate friends. Some of the accounts, particularly of incidents that involve Lowry's sentimental life, were given to different people in alternative versions which, when matched, cannot both be true. All the accounts are falsified when they deal with Lowry's means of livelihood between the ages of fifteen and sixty-five, which in fact depended on an embarrassingly plebeian and commercial employment.

Because this vital area governed later assumptions about his artistic development, Lowry not only told less than the truth: on occasion he blatantly lied. He allowed many people to infer or believe that he had always had money, that he had been an almost perpetual student, that his parents had left him a private income sufficient to survive on. But when he saw the necessity to lie direct, he did so. In 1966 Edwin Mullins was superintending the great Lowry Retrospective Exhibition at the Tate Gallery, and was preparing the catalogue commentary. Lowry made the following statement to Mullins, and perused it without protest when it was published in the *Sunday Telegraph* of 20 November 1966: 'Of course I often used to wonder if I'd ever make any money. I was living at home, so it wasn't urgent, but every now and then I felt thoroughly fed up and I'd say: "This is ridiculous: I'll take a job." But I didn't like the thought of going to the office with a bag in my hand at half past nine every morning. And then some little sale would come along – there were always a few private buyers in Manchester and Salford – and that was enough to keep me going for another year.'

The fact was that for forty-nine successive years Lowry had taken his bag to an office long before half past nine every weekday morning. After a period as office boy and insurance clerk, he served over forty-two years as, consecutively, rent collector, clerk, cashier, and acting secretary to a firm

of housing property owners from which he retired at the age of sixty-five on a pension which he later commuted.

Money enough for sustenance was never lacking; time and daylight were. By maintaining an astonishing intensity of production he painted all the 'great Lowrys' – the pictures being sold before and after his death at up to £35,000 – in the leisure hours snatched from a full working week. Whether or not the more disturbing paintings made after he had retired are greater has still to be determined.

The myth of Lowry's material struggle as an independent artist is only important because Lowry bothered to create it. The motive concerned his artistic struggle. He must have known that the myth could only last his lifetime. His reason for creating it was clear: 'The main thing, it seems to me, is to let the people know that I was trained. I'm tired of people saying "You're self-taught, aren't you?" I'm sick of it. I drew the life class. I did the life drawing for twelve solid years as well as I could, and that, I think, is the foundation of painting. I don't think you can teach painting, because everybody's colour sense is different. But drawing: the model's there, and you either get it right or wrong. There's no question of that. If you can draw the life you can draw anything.'

Lowry did his training – seventeen years at art schools and twelve solid years drawing in the life class – at evening classes, because he was working full-time during the day in an office in central Manchester, only relieved by days of tramping round the slums collecting working-class rents. It is facile to suggest that because of his commercial, un-Bohemian background he was despised by the art establishment of Manchester, and that consequently he tried to suppress as completely as possible any admission that he had not been a full-time painter. And so the myth was fashioned.

But the truth is more subtle. Lowry *was* despised by the art establishment of Manchester. The Manchester Academy of Fine Arts *was* self-consciously uncommercial, gentlemanly Bohemian. Moreover, it was an establishment of notable contemporary competence, by no means a dim provincial body. When Lowry first began to exhibit there, in 1918 and 1919, the Manchester Academy was still dominated by men of accepted prestige like the landscape artist George Gordon Byron Cooper, of whom

the great Lord Leighton, President of the Royal Academy, had said, 'I always know what time of day it is in Mr Cooper's pictures.' The Manchester Academy was still basking in the sunshine of this compliment although Lord Leighton had died twenty-three years previously. The contrast between Lowry's industrial exteriors, where there was not a single shadow, and Byron Cooper's landscapes, where every tree was a sun-dial and every peasant a spear-carrier for Father Time, was too pointed to be missed, and the younger man's glamourless urban figures excited no flood of bucolic warmth. Lowry's paintings were literally laughed at when they were hung.

Open laughter inside a gallery from the elders of his tribe is not a criticism that an artist can take lightly. Lowry severed his connection with the Manchester Academy, but through the twenties he was to endure many years of being cold-shouldered. The Manchester art establishment rejected Lowry because, in a superficial sense, they knew him too well. He had left art school at the age of thirty-five. He had been known there for seventeen years. It would have been futile to have pretended that he had been a day student rather than attending the night class. And, to give them their due, the local art world did not despise him for that. But they knew him, in their contemporary use of the word, as a queer fellow of long standing. Lowry was a solitary, from intensity of thought rather than deficiency of character: it was not that he was unsocial or uncommunicative, but that he needed to be wooed, and younger extroverts rarely had the patience to woo him. This odd man went his individual way, and when at intervals he produced odd pictures it was natural to laugh at them. Only when the tradition of ridicule grew, when the dismissive slogan 'He just can't paint!' spread to circles where it was not even known that he had slogged for seventeen years at art school, only then did suppression of the facts of Lowry's mundane daytime career become convenient.

At the time when his talent began to be recognised, around his sixtieth birthday, there were many people in Manchester – friends, business acquaintances, and the neighbours – who knew that Lowry held a job in the town. There was nothing very surprising in that fact. But during the next, swift phase Lowry moved from the neighbourhood he had lived in

for forty years, retired from work, and virtually cut himself off from all his old acquaintances. As the years passed, those who had known him died, and Lowry lived on for almost another generation in a new environment, choosing new friends and releasing selected items of history to them on an exclusive basis.

At times the direct question would be put to him, and he would savour the enjoyment of working up a dramatic passion as he launched into the answer: 'Unrecognised for thirty years? Tempted to give the whole thing up? Of course, of course! I had friends who came to me and said, "Why don't you give up this ridiculous game? You're out of your mind, you're lunatic! Come with us and we'll find you a job – you'd make a good stockbroker." But I didn't.' He would gargle an earthy chuckle. 'I couldn't go out in the morning and get down at half past nine with an attaché case and umbrella in my hand and a bowler hat on my head. I couldn't do it!'

Having fashioned the myth, Lowry even deceived those who helped him to build it, though he daringly gave them his motive. 'I know, I know,' he told a team making a film about him. 'Many people assume that I am technically incapable. That is what you have got to confute. You've got to get rid of the idea that I am untrained. You've got to show that I went for seventeen years to an art school, and I drew the life for twelve of them. If once you have drawn the life seriously, you can't do a job really outrageously. The great aim of this project is to convince people that I'm not a Sunday painter.'

Then self-deprecation broke through: 'Well, I *am* a Sunday painter. It's just that I paint every other day of the week as well.'

In this campaign of deception Lowry could claim, but only to himself, two major victories and one stroke of luck. The luck was that the one man from work whom he had not entirely sloughed off in his busy, publicised period of late fame did not immediately betray his secret to the press, but accepted Lowry's assurance that it would not matter if the truth were known after his death. The victories were more hazardous. The only friends whom Lowry retained from his early days were a bank official, Geoffrey Bennett, and his wife, Alice. Bennett, who later became a minister, knew Lowry for fifty years, and for the last forty of them the artist

used to stay at the house of Mr and Mrs Bennett from time to time at various places in the North. Never once during the twenty-six years of this friendship when he was working did Lowry mention that he had a commercial job, and the Bennetts, trustingly uncurious, never once asked how he supported himself. Then in 1951 the art critic Maurice Collis was asked by Alex Reid, the senior partner of the Lefevre Gallery, which had taken Lowry up, to write the now famous book *The Discovery of L. S. Lowry*. Collis came to Manchester, a place he had never visited in his life. Lowry was still working in the centre of the town, with eighteen months to go before his retirement. He managed to take the requisite time off and to conduct Collis around the Salford he had continuously painted and the art galleries of Salford and Manchester, dodging the casual, revealing conversation of all who saluted him, yet still introducing Collis for deep discussions with the curators of the two galleries and with Lowry's patron at Manchester University, Professor H. B. Maitland.

The visit lasted for a tense forty-eight hours, during which Collis perceived no anxiety and divined no secret. More than Maurice Collis knew, Lowry deserved the tribute which, from his teetotal but humorously unbigoted standpoint, he described Collis as making to him: ' "Mr Lowry," he told me, "you are a genius. Always remember that you are a great man." And he swayed with all the hot milk he'd been drinking.'

Although, as we have seen, many of his pronouncements were deliberately misleading, the character who is to move through these pages is – outside the monument of his art – best portrayed and best understood by his own speech. Physically he was always tall; in youth gangling and clumsy; in age never bent below six feet, never bulkier than fourteen stone; always formally clad in what seemed an eternal suit of clerical grey; a strong, muscular face with piercing grey-blue eyes and a great prow of a nose. His accent was mainline Manchester occasionally reaching back into the richness of Lancashire. The manner of his speech was very diversified. Like many solitary people who talk to themselves some of the time, he often indulged in an old-fashioned volubility, almost Dickensian in its wilful characterisation, the explosion of one sentence spontaneously setting off another, less important, and that leading to other muttered reverbera-

tions, like a benign roll of distant thunder or a short burst of shunting in a steam train: 'You like that picture? Do you really? How *very* interesting. I *am* pleased. You do me an honour, sir.' One talks to pets or infants in this way, but Lowry had neither, though he did conduct growling matches with other people's dogs and cats.

It was not that Lowry was garrulous. He controlled his outpourings and even shaped them artistically. As a lover of Bach he was perhaps offering his own fugato passages – a fugue has been neatly defined as organic growth out of small material. Here is his version – one of many variations – of an occasion in Winchester when he was sketching a bearded woman as she pushed a pram uphill, and she turned and swore at him for, as she thought, laughing at her: 'You remember that lady with the beard pushing the pram? People say they can never find subjects as grotesque as mine. Well, I saw her. I saw her in Winchester. A dreadful to-do, sir. Oh, the language! The language was appalling. I turned *pale*. In Winchester of all places, sir. I don't like to think about it.'

At times Lowry's controlled comedy in decorating his own mundane remarks seems to reach the impossible art of a conjurer who can keep butterflies, instead of coloured balls, indefinitely in the air and snatch them back at will. He once said to Robert Robinson, regarding the dismal home he set up for himself at Mottram, which he loathed: 'I have been meaning to move from here for oh, I don't know how many years. But I don't know where to go. I don't know where I'd *like* to go. I used to look at maps when I was a young man going on my holidays. And I couldn't see anywhere I wanted to go. In fact, if I looked at the map long enough I'd start disliking *everywhere*, very violently indeed.'

This was the speech of Lowry at ease, improvising brilliantly in the exhilaration of a social encounter that was comparatively rare; and perhaps echoing what he called 'the beauty of the writing' of Congreve and the Restoration dramatists whom he had read with such intensity and pleasure before his mother died.

There was another Lowry who was far more insecure, and showed it in constant enquiries to people of judgement on the subject of the lasting importance of his work. 'Will I live? Will I live?' was his recurring

question. When he refused the knighthood offered him by Harold Wilson he gave as one of his reasons the fact that if he really meant anything in the world of art it would not be known until long after he was dead, and that he was more concerned with those ultimate laurels than with the worldly recognition of a knighthood. When at a much earlier date – when he was sixty-six – the usual soundings were being made as to whether he would accept associate membership of the Royal Academy, he called on Humphrey Brooke, then the Academy's secretary, and asked, 'Frankly, sir, do you think me good enough to belong to an institution of which Sir John Millais was once President?' He became an A.R.A. in 1955 and he regularly sent in his quota of pictures. But he never sought parity with Academicians, never promoted himself to the art establishment, never even once attended an Academy Banquet. And before every Summer Exhibition, he sought out the secretary and asked with genuine concern, 'Tell me frankly – now frankly, Mr Brooke – are the things I've sent in any good?'

On the other hand, he did not seek flattery and could not absorb it. When art critics praise, they sometimes soar into extravagance. Every such volley of salute ricocheted off the Lowry iceberg:

'The painting of that picture is some of your finest work. That is a most technically accomplished painting.'

'Do you think so?'

'Hardly anyone realises what a remarkably civilised man you are.'

'Am I?'

'I am always comparing you with Hogarth.'

'Are you?'

'A man who could paint that magnificent *Shrimp Girl* and with his other hand, as it were, register and reform the urban squalor of the town. Like Hogarth, you have transformed the social scene.'

'Do you think I have really?'

'You're a very complex person.'

'Me? A simple soul. Everybody takes me in.'

When it was Lowry's turn to speak as an observer of the art world, he did so with shrewd irony and an accurate eye: 'Every week people write to me wanting to buy pictures. They haven't much money, but if I could

let them have a small picture for twenty pounds . . . It's surprising what a lot of people short of money write to me. I did have an American once who insisted on paying me more than I asked, but Americans are very good. An Englishman doesn't trust his intuition. An Englishmen will say, "I like that picture but I don't know whether I *ought* to like it. What shall I do? I'll have to wait and see what the general feeling is." An American comes into the house and stares about, and doesn't seem to be interested in anything, and then he says, "By the way, are you attached to that?" I say, "Not really, you know." He says, "I've never seen anything like that before. I'd like to take it back with me on the *Queen Mary*." And they are very good at that. That's the difference. The Englishman says, "I like this but I don't know that I ought to like it. Is it the right thing to like this man's work?" '

No catalogue of Lowry's modes of speech can ignore his stand-up comedy. He had served a long apprenticeship in the 'gods' of the Manchester music halls, of which there were some ten around the city before the Great War. Lowry never painted the music hall as such, though there is much music-hall presentation and panache in such street scenes as *A Fight* (1935) and *Father Going Home* (1962). (It is interesting that the individualist Walter Sickert, whom Lowry greatly admired and who was just one generation – twenty-seven years – older than Lowry and did his own scenes of the music hall, the streets, and the intimate aspects of domestic life, was like Lowry unrecognised in England until he reached his sixties, and became an A.R.A. in 1924 when Lowry was just beginning to exhibit.) Lowry had a good ear for dialogue. He never mimicked. But he did assume the expertise in economic presentation with which some of the northern comics told their jokes. Here is a narration – not exactly unrehearsed, for it had done Lowry distinguished service as a veteran among his recounted experiences – but certainly spoken spontaneously at the time it was taken down. With its pauses, its rushes, its constant changes of character and glimpses of character, it might have stood up usefully itself, and Lowry with it, on the boards of the Ardwick Empire.

'All the time I was working I was thankful when people called. Somebody would come in: "I say, old chap, if you're busy I'll not stop." "By

God," I'd say, "you mustn't go. I'll come with you!" But if you turn a man down you mustn't go into detail. One day a friend called, a client friend. I said, "I'm awfully sorry, I've got to go to London." I'd made a dreadful mistake. I said, "I'm going on the twelve o'clock train." I wasn't going, but I said it because I wanted to be by myself. "Oh!" he said, "I'll run you to the station." "Oh, no matter," I said, "don't bother." "I *will* bother," he said. So I picked up the first bag I could see and realised it was full of heavy books. I dragged this ridiculous bag into his car. He drove me to Manchester. I tried to get out before the station approach at London Road. He stopped the car. I said, "Thank you very much." "I'll see you off," he said. I thought, "My God! What have I done now?" I had to carry that bag of books all the way up the station approach. As we got to the ticket place I said, "Would you mind going over to the book-stall and getting me a *Times* and a *Manchester Guardian?*" I darted to the booking office and got a third-class single to Stockport. He came back with the papers and I said, "Thanks very much." "I'll see you off," he said; "I might as well now I'm here." I said, "Somebody might pinch your car." "What of it," he said, "it's well insured." Well, what can you do with a man like that? You can't do anything. So I got in the carriage and he got in with me. I was perspiring that he meant to come all the way. But they blew the whistles and he said, "I'd better get out." I heaved a sigh of relief, my word I did, and I waved to him *joyously* as he went. I got off at Stockport and dragged that bag down to a taxi rank. For the first time ever, there wasn't a taxi there. Eventually I had to hump it another half-mile to a bus. So never go into details in these cases.'

Lowry was also a master of what may be called the silent riposte. The best example of this took three months to mature. James Fitton, R.A., had been asked by the Member of Parliament Hugh Delargy, who had once represented a Manchester division, if he would bring Lowry along for a dinner at the House of Commons. Fitton mentioned this in a conversation with Harold Wilson, then Prime Minister, which had started innocently enough by Fitton's comment that Wilson had used a Lowry reproduction for his Christmas card that year. Wilson immediately over-rode Delargy's request, and instructed Fitton to get Lowry to appear at a dinner at 10

Downing Street. Fitton wrote a letter to Lowry telling him of the invitation. He had great trouble in composing this letter since 'Harold Wilson asked me the other day . . .' or 'I was sitting next to the Prime Minister when he suggested . . .' and other introductory sentences of that style seemed more in the name-dropping tradition than jaunty Jim Fitton could be credited with. But the letter was dispatched. It was not answered. Three months later Lowry met Fitton in London and they went round a few galleries. As they were going down Bond Street Fitton asked casually if Lowry had ever received his invitation to Downing Street. There was a freezing silence, and Lowry continued walking. After ten paces he gave his only acknowledgement. 'Yes, Jim,' he said. 'I '*ad* thought better o' you.'

Lowry strode steadily on, towards the Royal Academy of Arts, and away from the Patronage Secretary, the Prime Minister, and the Honours List.

Chapter Two

LOWRY came from a family whose origins were Protestant Irish on his father's side and urban Mancunian on his mother's. His grandfather Frederick Lowry immigrated as a boy from Ulster in 1827, and finally settled in Manchester. He built up a steady career as an estate agent, living in the heart of Manchester, which was little more than a pigeon's spit across the Irwell from Salford, in the parish of St George's, where he married a lady named Eliza Berry and set up house in Crompton Street. Their son, Robert Stephen McAll Lowry, was born there on 4 June 1857, and in shock or celebration his father, in registering his birth next day, recorded the second name as Stephens with an *s*, an addition which both Robert Stephen and Laurence Stephen ignored throughout their lives. Robert entered his father's profession but had not gone farther than the position of clerk in the office when in his mid-twenties he met Miss Elizabeth Hobson. She was the daughter of a master hatter, William Hobson, and his wife Ruth, née Hall, who lived over their business at 250 Oldham Road, Manchester.

Elizabeth Hobson was a sensitive, auburn-haired, delicate-skinned girl with a fine, thin nose overhanging a broad and volatile upper lip. She was from her teens an accomplished pianist and a devoted subscriber to classical concerts. Her son kept throughout his life a sheaf of Hallé concert programmes dating from when she was seventeen, long before she met her future husband. Like Robert Lowry, she was a regular worshipper in the Church of England at a time when church membership was a social as well

as a religious exercise, and she became organist to the Adult Ladies' Circle of the Bennett Street Sunday School, near her home in the Oldham Road at Ancoats. But her talent was higher than this activity might indicate. As a pianist she approached concert standard, and she was in fact engaged as an occasional stand-by accompanist in public performances at the Brand Lane concerts, a popular series corresponding to the Henry Wood Promenade Concerts in London (although – fulfilling the northern aphorism that what Manchester does today the rest of the country does tomorrow – the Brand Lane concerts were instituted fifteen years before the Queens Hall series).

In the late summer of 1885, when they were twenty-eight and twenty-seven years old respectively, Robert Lowry and Elizabeth Hobson were married and went to live at 8 Barrett Street, Old Trafford, three-quarters of a mile from St George's and two miles from Ancoats. Robert, still a clerk, promptly wrote a will leaving all he possessed to his dear wife Elizabeth, and he did not alter the testament during his forty-seven years of married life. He was a cheerful, sociable character who was reliable in the affairs of others but curiously feckless as far as his own material security or advancement went. He busied himself administratively with good works and encouraged local cultural life without having any great artistic appreciation of his own. Like a secular churchwarden he undertook responsibilities for raising and administering the finances of theatrical and musical enterprises. Lowry – slightly embarrassed because he could never do such a thing himself – called him a very good cadger, but said more bitterly, 'He was very good at getting other people to do things, but he could never do anything for himself.'

In Barrett Street, on 1 November 1887, the only child of Robert and Elizabeth was born, and was baptised Laurence Stephen Lowry. The baby bawled so much that it became a family joke that his father had to be held back from throwing him out of the window at the age of four months. They moved house on two or three occasions but settled fairly soon in the prosperous neighbourhood of Rusholme. The boy went to school in Victoria Park, then an enclosed housing estate gated against through traffic. The Lowrys had a large, comfortable house with space for Elizabeth's

growing collection of china and old clocks, and a music room where she played the piano. Lowry's clearest inheritance from his childhood was his pleasure in the music that his mother made.

Robert Lowry worked with a firm of estate agents in central Manchester. On Elizabeth's side the family had some social standing. Two bachelor uncles – in reality second cousins of Lowry's – were architects who throughout their long lives (both lived into their nineties) made memorable state calls on the family in their own carriage. An aunt lived in some style in London in fashionable Belgravia, and Lowry regularly went to visit her every month for almost fifty years. The aunt, more than Lowry's parents, seemed impressed by the child's early talent at drawing.

It seems a serene enough childhood, but Lowry was loath to talk about it. When he did, he insisted on his personal incompetence at everything and particularly at school, and even on his personal unhappiness: 'I hadn't a childhood that I care to remember. I didn't like being a child. My schooldays were a misery. I never passed one exam, because I couldn't. Far from being the best days of my life, it was not a nice time at all. I've no happy memories of my childhood.'

It has been suggested that his father may have had a drink problem and that this may have accounted for Lowry's rigid personal teetotalism, though that attitude was genial enough. There are no grounds for reading subjective trauma rather than general observation into Lowry's comic 1962 painting *Father Going Home*. There was no discernible edge in his voice when describing it: 'The face in the window is a little boy shouting out to his mother, "Mum! Dad's coming. Drunk again!" And she goes for the rolling pin.' But in a line drawing done forty years earlier – at about the same time that the classic local joke was formulated: 'The shortest way out of Manchester is a bottle of Gordon's gin' – Lowry showed a whole host of fathers going home down the same street in bacchanalian disarray, some of them swinging round lamp-posts by one hand with the greatest abandon. Though satirical, it is far more good-tempered than the grotesque propaganda of Hogarth's *Gin Lane*.

The family used to go for holidays to Lytham St Annes. The earliest surviving work of Lowry's is a pencil drawing of *Yachts* at Lytham done in

1902 when he was fourteen. The scene at Lytham was to be a recurring theme. He drew it constantly until the year before he died. In his forties, when he had developed his idiomatic representation of the industrial landscape, his mother could not appreciate the sombre style. 'I said to her, "Mother, then what do you want me to paint for you?" She said, "Paint some of the yachts we see when we are at Lytham St Annes." I painted the yachts and she loved the picture, and there it is on the wall, and I'll never sell it. That was in 1930, the year she became helpless as an invalid, and we never went to Lytham together any more.' This picture was still in his living room at Mottram, next to his portrait of his mother, when Lowry collapsed before his death.

When Lowry was fifteen years old he came to the end of his formal schooldays. His own version of his life-story takes its first notable lurch, from the truth here. Lowry's general guideline is: 'My parents saw me as useless. But there was enough money to keep me, and they loved me, and they kept me. I drifted into art, but they didn't believe in it, and did not think I could make anything of it. But what could they do? I was their son.'

To Edwin Mullins, Lowry said: 'It was suggested that I went in for art as I was fit for nothing else. At school I had few friends and I never passed any exams. An aunt remembered that I'd drawn little ships when I was eight years of age. So that was that. It was any port in a storm. I went to the Manchester School of Art in 1905 and stayed there a great many years. I was living at home, so it was not urgent to make any money.'

No specific statement could be more skilfully deceptive than this.

The truth is, as one of the few authentic archives in the Lowry saga shows, that in 1903 Lowry, aged fifteen, took a job as a clerk in the office of Thomas Aldred & Son, chartered accountants, of 88 Mosley Street in the centre of Manchester, and whether or not he had previously passed any examinations he at least applied himself successfully to learning shorthand and reached a speed of from sixty to eighty words a minute. He stayed with the accountants for over four years, leaving after his twentieth birthday in November 1907 to take up a position at twenty-eight shillings a week as claims clerk with the General Accident, Fire & Life Assurance Corporation of Cross Street, also in the centre of Manchester. He was

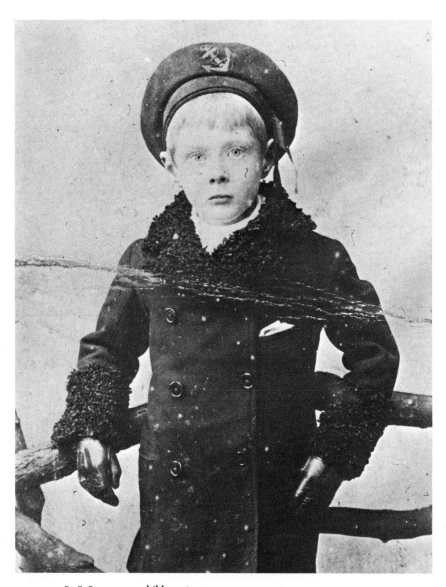

PLATE I L. S. Lowry as a child, *c.* 1894.
PRIVATE COLLECTION

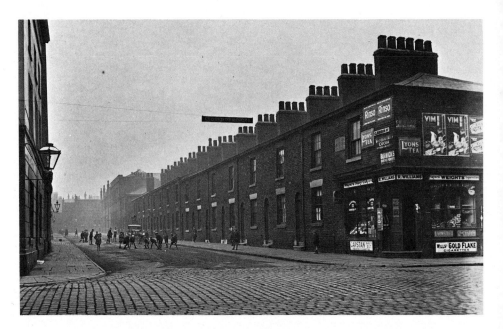

PLATE II Cleminson Street, Salford, in the early 1920s. Lowry tramped such streets as a rent collector.

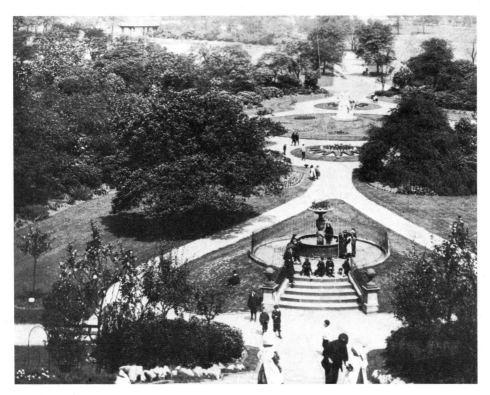

PLATE III Peel Park, Salford, from the steps, *c.* 1910 – a view which Lowry often painted.

PLATE IV Lowry's application to the Pall Mall Property Company, Manchester, 1910.
PALL MALL PROPERTY COMPANY LIMITED

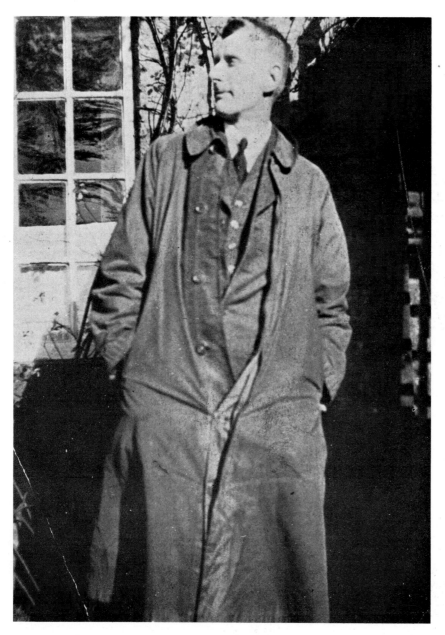

PLATE V The Manchester Man, complete with raincoat – Lowry, c. 1917.
PRIVATE COLLECTION

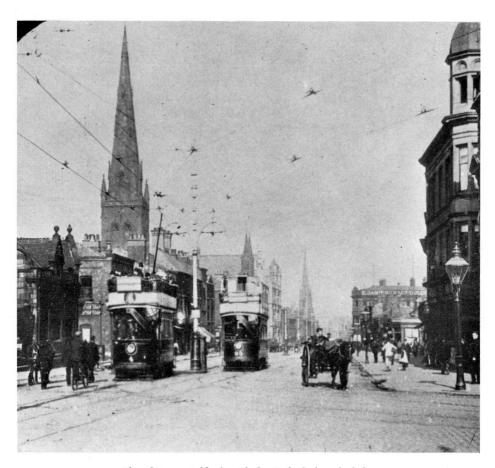

PLATE VI Chapel Street, Salford, with the Cathedral on the left, *c.* 1912.
V. I. TOMLINSON COLLECTION

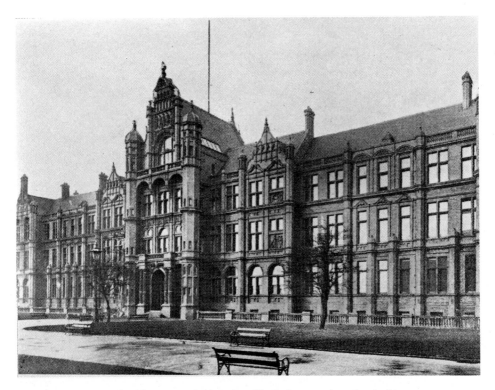

PLATE VII The Technical Institute, Peel Park, Salford, showing the School of Art wing,
c. 1910.
V. I. TOMLINSON COLLECTION

PLATE VIII Victoria Bridge Street, Salford, *c.* 1917.
V. I. TOMLINSON COLLECTION

made redundant in 1910, when he was twenty-two, and in the next month applied for and obtained a job as rent collector and clerk with the Pall Mall Property Company, being eased into the job by the fact that his father was working for a parallel estate agency called Earnshaw's. Lowry remained with the Pall Mall Property Company for over forty-two years, until he retired. The term 'estate agent', which is used widely in relation to the careers of Lowry's grandfather, his father, and himself, should perhaps be more clearly defined. In Victorian and Edwardian times a very common type of small investment by quite modest people was to buy a working-class house, which might be obtained for £300, and to let it as an additional source of income. The collection of the rent was carried out by an estate agency. Lowry's father handled this type of business and was also an insurance collector, calling at the door for insurance premiums – sometimes as little as a penny a week to cover an eventual funeral at which one could rely on being 'buried decent' – on behalf of the industrial assurance companies. When he went out rent-collecting, Lowry saw working-class life at close quarters, and later he used to say that meeting people in this way was a great help to his painting.

In 1905, Lowry went to the Manchester Municipal School of Art, going to the evening classes which were then attended in strength. The school was at All Saints, and there is an evocative picture of the ambience done by Adolphe Valette, who began studies there in the same year. Lowry went into the freehand drawing class, passed into preparatory antique, graduated to the antique class, and when they thought he was good enough and he had made some study of anatomy, he was declared a fit person to go into the life class. This progression took one year, and when he entered the life class he came under the supervision of its new master, Valette.

Adolphe Valette, eleven years older than Lowry, was a native of St Etienne, a manufacturing town near Lyons, and had moved to Lyons at the age of sixteen to work as an engraver and painter. After earning his living mainly as a commercial engraver – then a solid workaday craft before the take-over by photography – and continuing evening classes in Lyons, Paris, and Bordeaux, he won a travelling scholarship which enabled him to come to London to study painting. But he left the capital

for Manchester, possibly because his scholarship was meagre and he had to seek work. In 1905 he was doing commercial figure painting for a printer who supplied fancy labels and stock tickets to cotton goods manufacturers exporting to the Far East. And in the evening he studied at the night classes of the Manchester School of Art (the fact that Lowry worked in a chartered accountant's office is an indication of the varied milieu from which the school attracted its students). In the next year Valette joined the staff of the School of Art and took over the life class. At the same time Lowry, then aged eighteen, was permitted to join the life class.

Sir John Rothenstein said that Lowry told him: 'I cannot over-estimate the effect on me at that time of the coming into this drab city of Adolphe Valette, full of the French Impressionists, aware of everything that was going on in Paris. He had a freshness and a breadth of experience that exhilarated his students.'* In more recognisable phraseology Lowry told Mervyn Levy: 'I owe so much to him for it was he who first showed me good drawings; by the great masters. He was a real teacher, sir – a dedicated teacher.'† In fact, however, and particularly in 1956, Lowry was unimpressed by the French Impressionists, who revealed to him no awareness of what he called The Battle of Life – a tension of which he became increasingly conscious and which he sought to express more and more in his work as he grew older.

Lowry consistently said that he 'drew the life' for twelve years, that is, up to about 1918, out of a longer period of art study. From other evidence, it is likely that he actually stayed on at Manchester for a longer term, probably until he was thirty-two. He is known to have attended the Salford College of Art on a much more intermittent basis following his long stint in the Manchester life class. In unguarded moments, or yielding to his tendency to self-belittlement, Lowry said that he was finally asked to leave the school. At other times he wryly said, 'When I broke the sad news to them that I was leaving they tried not to look happy about it.' As James Fitton recalls it, a new type of student came into the school after the Great

* *Modern English Painters*, 1956.
† *Painters of Today: L. S. Lowry, A.R.A.*, 1961.

War. 'They were men of Lowry's age, people of experience who had been through the fighting in the war, and had got Government grants to study art. Against these people Lowry stood out as even more of an oddity than he had seemed by comparison with us younger people, who over the years had come to accept him.'

Undoubtedly Lowry enjoyed himself at art school. 'I saw people there, I liked the life. It was good to meet people there. My temperament made me very unsociable although that was not my wish. Mind you, you couldn't just walk into the life class in those days. There was quite a stringent appreciation of your work before you were accepted. I did not draw the life really well. I was competent. But I did find it valuable, and I still believe that long years of drawing the figure is the only thing that matters.'

James Fitton is quite blunt about Lowry's performance in the life class: 'He would make a swipe from the neck to the ankle that might have been carved with a meat-axe. He had no feeling for subtlety of line, for that matter no feeling for the female form divine. It was not that he did not understand the answer – he could not find the problem. Valette, however, treated him very magnanimously. Valette was a venerating disciple of Degas and therefore he venerated drawing, draughtsmanship. He could have pasted into Lowry and torn him to shreds. I think what he did was to decide that Lowry was unteachable, and so he gave up precise ambition for him but never ceased to nourish him. There is a potential artist in everybody if people can do their own stuff once they've learned the fundamental discipline. If you confront an artist with what you might call the grammar of the craft – that you can't express *this* without doing *that* – if the artist accepts this and has any creative ability then he will come through. Valette realised pretty early that he would never teach Lowry to draw like Degas. Fortunately he was not an aggressive chap. So when he had come up on Lowry, observed his work in silence for some time, and swiftly jotted the notation of an amendment on the side of the paper, he passed on, not censoriously but radiating enthusiasm.'

James Fitton came from Oldham to Manchester to study at the School of Art when he was fourteen and a half years old. The fee for attendance at

evening classes was seven shillings and sixpence a term (as a control, Lowry, paying the same, was then earning about two pounds a week), and Fitton got even that remitted pretty soon. He did distinguish a certain snobbishness among the more prosperous day students against those who were forced by their circumstances to attend at night. Fitton speedily joined the life class where Lowry, then in his twenty-ninth year, had been in occupation for some ten years, and they worked together in this class, often for a full stint of five nights a week, with occasional pressurised remands to get some service in in the antiques class, and a temporary explosion against the fancied corruption of Fitton's youthful virtue.

In spite of the difference in their ages, Fitton and Lowry became companions. Fitton was working at a night job in the docks, and after the classes Lowry would walk with him to the dock gates and talk over a cup of coffee in a dockside café. 'Even in those days,' Fitton recalls, 'Lowry very much underplayed the fact that he had a daytime job, and he didn't like it to be mentioned.' Fitton saw Lowry as what the Manchester art establishment called him then and later, 'a dogsbody', an oddity. 'He expressed no idea of becoming a professional painter. He seemed to have no ambition for success. He gave the impression that he was painting because he had nothing better to do. He regarded it as an activity which passed the time in the same way that a man might regard working in his allotment.' This assessment, made at the time that it was, is an interesting commentary on Lowry's remoteness, reserve, or ambivalence. For it was made *after* Lowry's sudden conversion to the perception of beauty in the mean streets which he dated precisely as 1915: 'I was inspired . . . At first, when I was young, I did not see the beauty . . . Then I suddenly saw it . . . I was with a man and he said, look, and there I saw it. It changed my life. From then on I devoted myself to it.' He was not unique in his approach, however.

'I had a night job,' said James Fitton, 'energetic, but a short shift, and as soon as I was awake in the morning I would be back at the docks drawing. On Saturday afternoons and Sundays Lowry and I used to take our sketchbooks and go up the Oldham Road. People say it's the most dreary seven miles in Britain, but we didn't find it so. The mills and company houses

gave it a unity that was marvellous. But Lowry was not a chap you could walk with very easily. He was not only gangling and weedy, but he walked with a sort of bias. Every so often you felt yourself being urged by his shoulder and hip diagonally into the gutter. Sometimes we took water-colours and did vaguely impressionist studies at Heaton Park, Daisy Nook, Boggart Hole Clough, or Northenden. One wet Saturday afternoon in the early 1920s Lowry said we were going to the theatre. I thought we were off to see Miss Horniman's company in Ibsen's *Ghosts* at the Gaiety. We paid fourpence and got up to the gods of the Hulme Hippodrome, and saw Fred Karno and *The Mumming Birds*. Lowry never stopped laughing all through it.'

Fitton's companionship with Lowry within the orthodox life class at the School of Art was interrupted by an official concern for his virtue. There was a standing rule that men and women could not attend a sitting together when the subject was a female nude, but Valette was not rigorous in barring students on the ground of their age, and Fitton had been admitted to the life class while he was still fourteen. A few months later the Art School was subjected to a visitation by the Bishop of Manchester. In the life class he was less interested in the quality of the art than in the age of the students. He absorbed the prospect of a nude model in the middle distance being delicately drawn by Fitton in the foreground. He gazed in disbelief, and thundered, 'How old is that boy?' He was told. 'He is being corrupted!' decreed the bishop, and Fitton was ordered out with Charles (Bert) Wilson, who was the same age. But one of the girl students per-suaded her father to let her have the use of an empty warehouse belonging to him. A group of students were invited, and for a considerable time they conducted their own life class every weekend: a mixed group of men and women including the fourteen-year-old Fitton. At the other end of the scale, thirty-year-old Lowry was included – some measure of the rapport he had built up with youngsters mainly ten years his junior. The students took it in turns to strip and pose, but this additional requirement was not imposed on Lowry.

Observing Lowry's social reactions at the time, Fitton concluded that his 'elderly' friend was unmoved by women. 'The art school was lousy

with beautiful girls and you would expect anyone to be bowled over. But as far as Lowry was concerned they might have been a collection of police-women. He was certainly not homosexual, but I did regard him as neuter. He was decidedly not the person for whose benefit you would introduce a sleazy joke into the conversation.'

James Fitton is the first to admit that he was not then of an age to be outstandingly perceptive of the psychology of a man in Lowry's position. Lowry was not sexless, though he was vastly inhibited and his emotions were complicated by an intense devotion to his mother. From the age of twenty-five he experienced a number of attachments characterised by a dumb devotion usually felt by adolescents. One girl died young, when Lowry was twenty-six. Another, a student named Dora, married another student at the art school, Charles Holmes, although she did on occasion quizzically hint that she had been invited to be Mrs Lowry. In his old age Lowry would make a characteristically guarded reference to one shy romance. He told Edwin Mullins: 'I've never had a girl. And now I'm nearly eighty I think it is too late to start. There *was* one girl: at art school. We met in life class for three years, and used the same railway station to go home. It went on like that. When the summer holidays came we'd say, "See you again in October." I never thought of arranging to see her. And then one October she wasn't there, and that was the end of that.'

It was not, in fact, the end. Lowry tried very hard to find out where this girl was. He believed she had gone away and was married. Much later he had a hint that she was back in the Manchester area. He tried to follow up the information, but it led nowhere and he did not trace her. He was then in his seventies and she would have been in her sixties.

At no time was Lowry unaffected by women. But during his physical maturity he was not temperamentally equipped to deal with women – indeed he was very sparsely equipped to deal with anyone in a free personal relationship. It was hardly the voice of a sage vibrating when he made his most profound general statement on women: 'Some are very decent. They've got their own way. They're quite different from men. But you've got to realise that they are different from men and adapt yourself, and

you're all right. Generally, of course, if you want to do something they suggest doing something else.'

Ill-equipped as Lowry always was, it is fair to say that much later in his life, when success came visibly to him – and this was delayed until he was in his late sixties – he developed more confidence in his relationships and in his art. The confidence can be seen in his pictures, and his personality mellowed so that he began to be sufficiently at ease with women strangers to be playful – verbally. He was glad when young girls were brought into his company: his eyes lit up and his voice audibly softened when he addressed them; he began to be gallant. His baptism of fire in this connection occurred when he was appointed visiting painter to the Slade, and the girls there, it was reported, 'fell over him with an abandon that would have made Augustus John's flesh water.' In his later years Lowry was even master enough of his sexual situation to tease a friend of fair intimacy by appearing to tolerate some abstract discussion that might by deduction yield a clue as to his virginity. (He was, in fact, an entire virgin, as his few real friends knew.) Occasionally he would advance the situation by a daring leap of generalship.

'Of course, you have never married, Mr Lowry,' said one devious inquisitor, moving into slow action like a chess player advancing his bishop.

'No,' said Lowry. And then with an impulsive burst he seemed to decide on a destructive move of exposure. 'I used to worry about that,' he confessed. 'I thought there must be something wrong with me. I worried so much that in the end I went to see a doctor.'

'Yes?' said the interviewer, hushing against a fracture of the mood.

'He examined me very thoroughly.'

'Yes?'

'Then he said a very hurtful thing.' Lowry paused in bitter reminiscence.

'What did he say, sir?' came the eventual question.

' "My God, you're ugly!" '

In 1909 Robert Lowry moved with his wife and son from Rusholme to Pendlebury in Salford, then a very busy and unkempt area of the great Lancashire cotton-manufacturing complex. Socially it was a come-down: Pendlebury was an industrial wasteland compared with the exclusive

avenues of Victoria Park. Logistically it was inconvenient: father and son both still worked in central Manchester, which was now five miles away instead of two and was not so efficiently served from Salford. Economically it may have suited Lowry senior: property prices were lower. Elizabeth was certainly isolated. Lowry said that not only did he himself intensely dislike the change, having lost all his old acquaintances, but that his mother never accepted Pendlebury and made no friends there. She did in fact become a recluse and an invalid, and for the last quarter of the thirty years of life that remained to her she never left the house. There is a resignation about her already in the water-colour which Lowry did of his mother in 1909 and which he always kept.

But the house, then identified as 5, Westfield, Station Road, and later numbered 117 Station Road, was capacious enough, a sizeable semi-detached, and Lowry himself – though he afterwards said he was painting all day – was leading a very active life which made him virtually a transient sleeper in it. After he changed his job in 1910 he had a rent round which took in every quarter of the compass around Manchester. He had no time to get home before going to night classes. He had his sketching excursions at the weekends. Art school holidays, which at least restored his evenings to him, offered the only extended time to attempt serious painting. And he was producing work worthy of consideration. Apart from loyal portraits of his parents he had tackled his first significant industrial subject in a pastel of a *Mill Worker* (1912), and his first notable 'urban landscape', *Selling Oil-cloth in the Oldham Road* (1914), of which Eric Newton said forty-five years later, 'The paint is conventionally "arty" but the vision is already his own.'

In 1912, significantly the year in which Lowry drew the *Mill Worker*, he had an experience which he consistently referred to as almost mind-changing. He saw Stanley Houghton's new play *Hindle Wakes* in its production by Miss Horniman's Repertory Company at the Gaiety Theatre, Manchester. The play was produced by Lewis Casson and one of the actresses was Sybil Thorndike. *Hindle Wakes* is one of the few plays in English drama which merits the over-used term 'seminal'. It was in its time a revolutionary play presenting a new realism, sympathetic but

unsentimental, in its portrayal of types supremely foreign to the conventional stage: neither fashionable London-orientated upper class nor lovable rustics nor over-eloquent theorists, but representatives of the great humming hive of humanity which the nineteenth century had casually spawned and culturally ignored – in this case the working class and the first-generation industrial plutocracy of industrial Lancashire.

The plot of the play is a projection of the conflicts involving the 'New Woman' which H. G. Wells first aired in *Ann Veronica* in 1909. Ann Veronica is an unfaltering middle-class intellectual character. The heroine of *Hindle Wakes*, Fanny Hawthorn, is a weaver who has had a weekend affair with the son of the boss of her mill. Her father, who is a childhood friend of the boss and maintains some intimacy with him though his position as a slasher puts them into the relationship of master and man, insists on an immediate marriage and the lad's father eventually agrees even though it will mean breaking an engagement to marry the daughter of another nouveau-riche. Fanny Hawthorn refuses: 'No fear! You're not good enough for me. The chap Fanny Hawthorn weds has got to be made of different stuff from you, my lad. *My* husband, if ever I have one, will be a man, not a fellow who'll throw over his girl at his father's bidding! Strikes me the sons of these rich manufacturers are all much alike. They seem a bit weak in the upper storey. It's their father's brass that's too much for them, happen! They don't know how to spend it properly. They're like chaps who can't carry their drink because they aren't used to it. The brass gets into their heads, like! You're not man enough for me. You're a nice lad, and I'm fond of you. But I couldn't ever marry you. We've had a right good time together, I'll never forget that. It *has* been a right good time, and no mistake. We've enjoyed ourselves proper! But all good times have to come to an end, and ours is over now.' Fanny is thrown out of her home, and still refuses to take help from the lad: 'It's right good of you, Alan, but I shan't starve. I'm not without a trade at my finger tips, thou knows. I'm a Lancashire lass, and so long as there's weaving sheds in Lancashire I shall earn enough brass to keep me going . . . I'm not going to disgrace you. But so long as I've to live my own life I don't see why I shouldn't choose what it's to be.'

The only comment Houghton allowed to the mill-owner is, 'There's no fathoming a woman. And these are the creatures that want us to give them votes!' This play, forcefully written and strongly radical in the Manchester, literal, sense, had a lasting influence on L. S. Lowry and he often referred to it. It is idle to try to trace its ideology in his art. There is no revolutionary 'message' in his work, and the multiple images of the proletariat which he paints are never aggressive. Nor, for that matter, are they particularly downtrodden in any propaganda sense that would raise a cry for liberation; but a comment by James Fitton is interesting – that Lowry handled his crowds 'decoratively, like Eisenstein'. The only ideology inherent in *Hindle Wakes* which was ever reflected in Lowry is an implicit support of the suffragette movement. This is the only radical tendency to which Lowry ever confessed. Both his father and he himself supported the suffragettes, though Lowry did nothing active about it, and his own justification for his feelings is curiously restricted to a narrowly material basis: 'There was no reason why, if they had to pay rates, they shouldn't have the vote. It didn't seem fair to me.'

What may have been the strongest influence of the play on Lowry is its visual impact. The Gaiety settings were detailed and realistic – both the kitchen of the slasher's terraced house, 'rented at about 7*s*. 6*d*. a week', and the solid breakfast-room of the mill-master's vast house 'of the sort inhabited by wealthy manufacturers who have resisted the temptation to live at St Anne's-on-the-Sea, or Blackpool'. One visual feature which would be trivial now, but was stunning at the time, captured the eye as the curtain rose for the first act. 'Through the kitchen window can be seen the darkening sky. Against the sky an outline of rooftops and mill chimneys. The only light is the dim twilight from the open window. Thunder is in the air.'

Was the Gaiety Theatre offering Lowry a revelation?

The scales finally dropped from Lowry's eyes, if one accepts his own version, in the year 1915 at a patch of waste land called Stump Park in Pendleton. He later said he had drawn the location a hundred times afterwards, and Eric Newton acquired one of these records, which, unlike most urban scenes by Lowry, is said to be accurate. Stump Park had a

cinder surface, was little more than ten houses square, and was no park at all, not even a vehicle park: the stone stumps had been driven in to stop any such use. It was here that, in Lowry's words to Maurice Collis,* 'I was with a man and he said, look, and there I saw it. It changed my life.' Lowry had not created beauty. It was there. He recognised it. He was inspired by it.

As in most conversions, of course, there had been a long, if unconscious, preparation, though reference to this was generally extinguished by the drama of the moment of conversion itself. Lowry had lived for six years in Pendlebury. He had been appalled at first by the unloveliness of its industrial aspect. But he did change his attitude. An undramatic, musing account, recollected in tranquillity, shows a steadily changing interest and a repeated association with *Hindle Wakes*:

'We lived on the residential side of Manchester until 1909, when we went to Pendlebury, midway between Manchester and Bolton, which in those days was a particularly industrial area. The whole stretch from Bolton to Manchester was entirely industrial. At first I disliked it. After a year I got used to it. Within a few years I began to be interested and at length I became obsessed by it and painted nothing else for thirty years. I was very interested in Stanley Houghton's play *Hindle Wakes* in those days. It's a very good play. I began to look at the industrial scene. The thought came to me: "Nobody has done this, I'll have a shot at it. I'll have a go at getting this established as a legitimate subject matter." This would be 1912 and 1913, before the war. I did a lot of walking in those days, I was a good walker. And almost every Saturday night, particularly in winter, I would walk from Pendlebury to Bolton. I chose Saturday night because there was more life on a Saturday night, and I chose Bolton because I thought – still think – it's much more alive than Bury and other places. I used to set out at about half past four, walk to Bolton, go to a café and look around and drift back some way, possibly by train, all sorts of ways. At Kearsley there used to be a colliery that went right across the road. As you walked towards the colliery you could hear the clanking and thump of the engines

* Maurice Collis, *The Discovery of L. S. Lowry*, 1951.

getting louder and louder, and then you would be on it, and then you would pass it and the sounds would fade. I would carry that impression in my mind all the way to Bolton and it would be with me when I sat down in Seymour Mead's café, and I suppose I would forget it in the main streets because I liked the life and the bustle. But it would come back to me as I took my way home. That's how my obsession with the industrial scene started: Saturday night walking the road to Bolton, and hearing the thump, thump of the machine at Kearsley Colliery. And coming back in the dark: thinking and thinking, thinking of the mystery of it all.'

This is a more prosaic and possibly more credible account than the poetry and panache of 'I was with a man and he said, look, and there I saw it.' (This man has never been identified.) There is an even more matter-of-fact presentation of the new subject matter for his work. 'My subjects were all around me,' said Lowry. 'In those days there were mills and collieries all around Pendlebury. The people who worked there were passing, morning and night. All my material was on the doorstep.'

Something else on the doorstep was the conflagration known as the Great War, 1914–1918, which Lowry seems hardly to have noticed, or else to have expunged from his mind. It killed over a million Britons. Lowry was twenty-six years old when it started, and thirty-one when it finished. Yet he has not left a single written or artistic reference to it.

He did not enlist voluntarily, and when conscription was introduced in 1916 it passed him by. Lowry later said he had been declared unfit, but never went into any details. He also said that a life insurance company had declined to insure him in 1910, giving him a medical examination and then abandoning him – according to Lowry, without giving him a reason. Again according to Lowry, he was called up for the Army on several occasions but he was always rejected, with no other reason given than the jocular 'We'd be pretty hard up if we had to use you.' Alick Leggat, who was close to Lowry through the last thirty years of the painter's life, once challenged him about this vagueness. 'What were the grounds on which you were rejected? What do you mean, you don't know? When you got home the first thing your mother would say would have been: "Laurence,

did they take you?" And you'd say "No", and she'd say "Why?" Now, why?' But Lowry still hedged over giving a reason, and diverted the confrontation into an anecdotal escape-route: 'Some years later I met the bloke who had failed me at my medical and he said, "My God, are you still alive?" ' It was a treatment parallel to the tactics used to deal with the conversational approaches about his virginity.

So Lowry got on with his rent-collecting and with his growing interest in the industrial subjects all around him. He did not make a sudden volte-face artistically. One of his somewhat over-aired moans was, 'I did landscapes that nobody wanted, then portraits that nobody wanted, then mill scenes that nobody wanted . . .' At this period Lowry was still drawing and painting portraits. There is a remarkable series of portrait drawings now in the Southampton Art Gallery. One of them is of George Parker Fletcher, the brother of Frank Jopling Fletcher, whose portrait in oils is now in the Salford Gallery. Lowry did not always have the best of luck with his portraits. One commissioned in oils was completed, but the subject had died before Lowry could get it to him. The portrait lay in Lowry's studio for thirty years, but he had it cleaned, because he liked it. Critics have called it the best portrait Lowry ever did. It is in a private collection and has never been shown to the public. Of another portrait he said: 'I did it specially to please the man. It seemed a decent bit of work to me. I hadn't reckoned with his wife. She took one look at it and refused to have it hung in the house. I think it was in their attic for forty-three years. After that the man understandably died. His wife had died long before. So it was inherited by his son. He did not fancy it at all, and I thought, goodness me, that painting is going to spend another generation in the dark. So I got it back and gave it to Salford.' Of another portrait Lowry complained that it was painted full-length, disliked, stored in an attic, and finally cropped so that only the head and shoulders were hung.

Lowry was also painting landscapes at this time, from the impressionistic to the pastoral. (As an indication that they were 'landscapes that nobody wanted' it may be noted that Alick Leggat bought a good oil painting of Peel Park by Lowry in 1948 for the sum of thirty shillings.) Lowry still accompanied his parents on holidays at Lytham St Annes, and made

sketching trips inland into the Fylde countryside, where it seems he had a cloudy infatuation with another girl.

He was still attending his evening drill at the Art School, but surviving examples of his academic work of the period are far less captivating than the imaginative original work he was now producing. And these really were imaginative productions, as Lowry has explained: 'Very often I worked on the canvas entirely from memory. At other times I would make reasonably careful sketches on the backs of envelopes or scribbling paper like that. Then I would take that back inside to make a careful drawing, and do the picture. But I liked in those days to do a picture entirely out of my mind's eye, straight on to the canvas. It was difficult to start, but you put something down, add to it, and suddenly you find you've put in some rather nice things and you're going along very well. It's like having to write an awkward letter. Once you've got a start to it you find it's not all that difficult after all. Oh, I liked that, to do a picture out of my head on the blank canvas. I think it gets nearest the truth, because there are no facts to hamper you, and you are setting down something that comes entirely from your own imagination.'

'Had I not been lonely, I should not have seen what I did' is the famous remark attributed to Lowry by Maurice Collis. In 1918 Lowry, fired with his own private vision, was allowed to become a student member of the Manchester Academy of Fine Arts, and this gave him the privilege of exhibiting at the end of the winter session. It was at this point that he was exposed to the open ridicule of the establishment artists. Lowry withdrew, but he did not stop painting.

Chapter Three

IN 1919, LOWRY became aware of the influx of new, harder, and more unsympathetic types among the ex-servicemen students at the Manchester School of Art. Eventually, not exactly in Lowry's music-hall phrase 'by popular request', but with the undisguised agreement of the authorities, he left the school. He did not entirely abandon his high evaluation of the training which, he believed, his 'competent' work in the life class was affording him. He became desultorily affiliated to the Salford School of Art and, after 1925, got the approval of his old master Adolphe Valette to go to the life classes which Valette was superintending at the Manchester College of Technology. Valette left Manchester in 1928. It is clear that Lowry was involved with art schools for well over half his life and all of his adult life until he was forty.

Taking stock in the early 1920s he could perceive that he was halfway to the grave, his parents were over sixty and by no means prosperous, he had sold one picture in his life and that had been banished to an attic, he himself was earning little more than two pounds a week at the Pall Mall Property Company, and even his material future was precarious. 'I woke up one morning,' he said, 'and realised, "If I were to die today there wouldn't be enough to pay for the funeral." From that moment I started saving.' Little by little he bought War Loan. It was a shrewd decision. Over the following years the price came down until it was little more than thirty pounds. At a rate of $3\frac{1}{2}$ per cent it was eventually giving him a 10 per cent annual interest at a time when inflation was not significant. Finan-

cially it meant as little security to him then as the penny-a-week burial
club subscriptions his father was collecting. But if an insurance doctor met
him again and queried sceptically, 'Are you still alive?' the resulting shiver
in the spine might be less acute. The public owed him nothing. 'I remem-
ber a young gentleman', Lowry once said, 'complaining after he had had a
show at a gallery that he had sold only one picture, and he was sending up
a strong moan about it. "You've really no grouse," I said. "When all is
said and done, nobody asked you to paint these pictures. It's quite fair. We
can't expect to sell to people who haven't asked us to paint." All I myself
was hoping for was that people would eventually get to like my work, but
I didn't feel that I could expect them to buy it.'

Lowry stayed in War Loan until his death. His other substantial holding
was in Ship Canal shares, acquired more out of perspicuity than from
devotion to his locality. But Lowry was both a loyal and a typical Man-
chester Man. The term has now lost its significance but it meant much in
its time. 'A Manchester Man' was originally a defensive phrase of inverted
snobbery to combat the other current definition, 'a Liverpool Gentleman'.
Liverpool then had the greatest cotton market outside New York and the
greatest grain market outside Chicago. Manchester was the great proces-
sing and exporting area. In levels of status it was thought more admirable
to make money out of commodities and raw materials than out of pro-
cessing them. That was one of the conventions of the time which nation-
ally is not quite dead, though Liverpool itself is now a derelict city.
Manchester men were content to be seen in the daytime in the nondescript
hats and incredibly grimy gaberdine raincoats which were a sort of prac-
tical outdoor industrial overall against the acid and literally abrasive grit of
the area at a time when smoke-abatement was an uncoined cliché and the
falling soot was sharp enough to cut your neck between collar and skin.
(It should perhaps be pointed out that Lowry's savage portrayal of *A
Manchester Man* in 1936 was a product of near-insane stress caused by the
illness of his mother, and should be viewed as a sick self-portrait rather
than a comment on his peers.)

After office hours Manchester doffed the raincoat and became a place of
lively culture. The city's forte was an enthusiasm for music. Apart from a

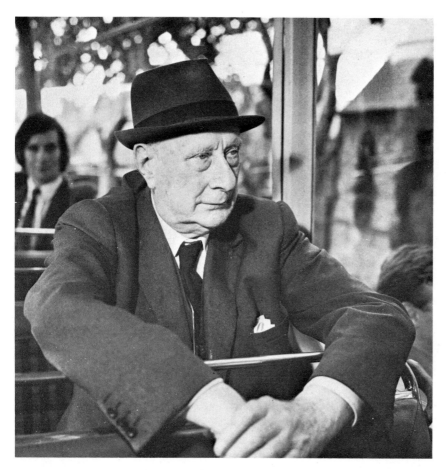

PLATE IX Lowry on a bus in Seaburn during the filming of Tyne-Tees Television's documentary *Mr Lowry*, August 1968.

TYNE-TEES TELEVISION LIMITED

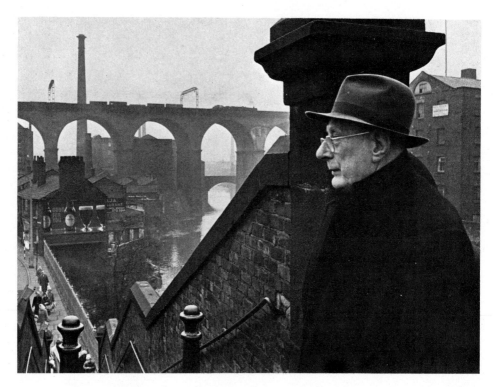

PLATE X Lowry in front of Stockport Viaduct, Winter 1962.
CRISPIN EURICH

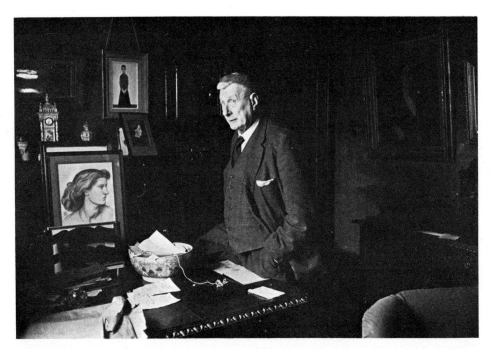

PLATE XI Lowry in the dining room at The Elms, 1962. The china bowl contains unheeded mail; behind is one of the Rossettis.

CRISPIN EURICH

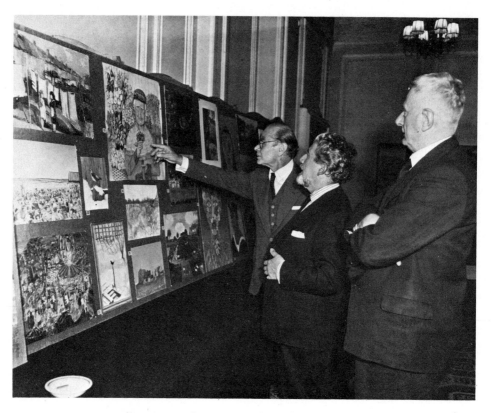

PLATE XII The artist with Mervyn Levy and Sir John Rothenstein at the Royal
Academy in the early 1960s.
LONDON PRESS PHOTOS

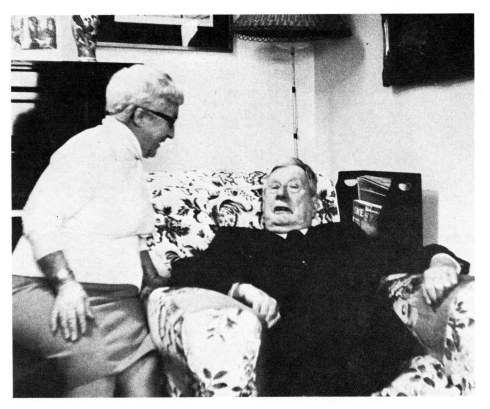

PLATE XIII Lowry with Mrs Martha Lowry at her flat in Rochdale, August 1968. He was a regular visitor for Sunday dinner.

TYNE-TEES TELEVISION LIMITED

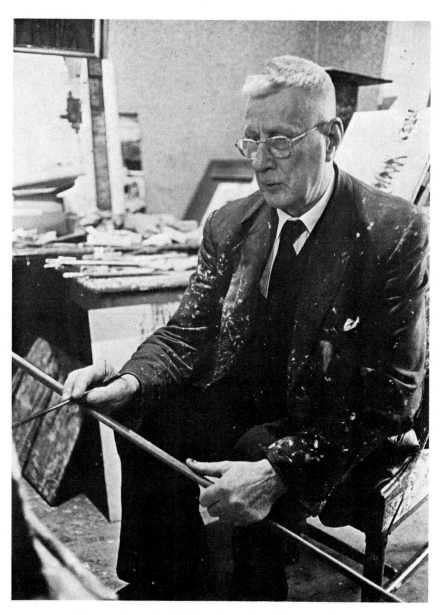

PLATE XIV The artist at work in his studio at The Elms, 1962.
CRISPIN EURICH

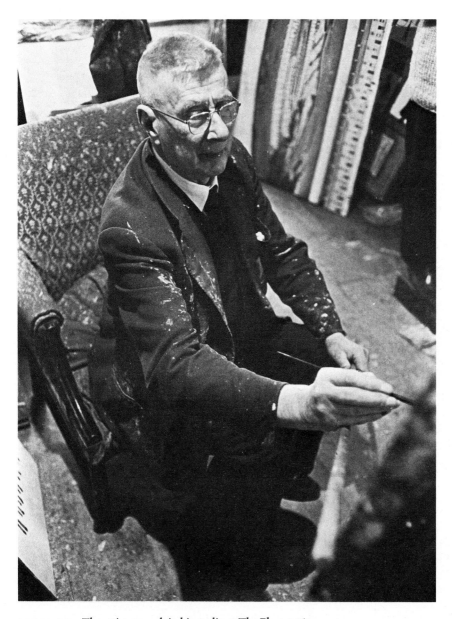

PLATE XV The artist at work in his studio at The Elms, 1962.
CRISPIN EURICH

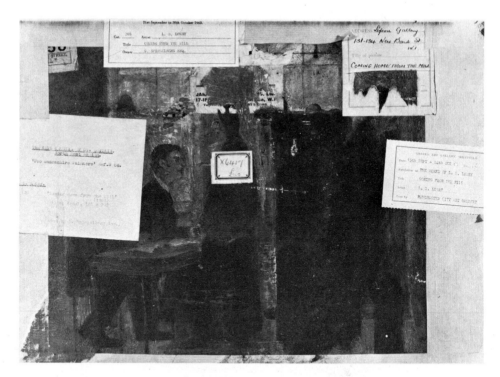

PLATE XVI The back of the painting *Coming from the Mill*.
CITY ART GALLERY, MANCHESTER

natural penchant for song, this was less a native growth than an implant from the German bourgeois immigration into the booming Lancashire cotton trade. Sir Charles Hallé, who founded his concerts in 1857, was born in Westphalia and came to England in 1848 when he was thirty years old, to be accorded by his keen compatriots and the many they had influenced a vibrant second home in Cottonopolis: Manchester was far less frequently dismissed as 'provincial' in his day. Later, Hallé's wife, the remarkable Wilma Norman-Neruda, was appointed violinist to Queen Alexandra. In the same tradition, Manchester artists were extended a certain national status.

Lowry settled down to consolidate his style. It had to centre on what he called his 'obsession' with the Lancashire industrial scene. There was no conscious motive of exposing the aftermath of the Industrial Revolution at this time. Lowry had come to like what he saw and was voicing no protest. John Berger said later that Lowry's paintings of industrial landscapes mirror the twentieth-century decline of Great Britain. This might be read into the unpeopled desolation of *Bargoed* (1965), but when Lowry began his forty-year onslaught on the industrial scene the nation was not catastrophically declining and his own interest was visual rather than intellectual. 'I painted these subjects as I saw them,' he said. 'I was very interested in them because I lived among them. They were remarkable pictorial subject matter for me.' Later he began to see them as scenes which ought to be recorded and which no one else had seriously tried to represent. 'I set out to put the industrial scene on the map,' he told Stanley Shaw, curator of the Salford Art Gallery. When he was reminded by John Maxwell, who was preparing a book about his paintings, that the industrial landscape was vanishing but his paintings had placed these scenes in our history, he exclaimed with perhaps over-indulgent hindsight, 'That is exactly why I painted them.'

He had an extraordinarily long spell of studio exercise – it can hardly be called tuition – behind him, but it had been restricted to the life class. It was the drawing that he wanted to conquer. He claimed that he had never had a lesson in design in his life. 'I think that's the best attitude. To me design is a natural thing and cannot be taught. I think my design is good.

A gentleman of the press once said, "His design at times is so intricate that it does not look at first like good design." That was very perceptive. Mind you, I think a great deal about the design, in my head before I start painting.'

Lowry's painting was becoming entirely original in the individual convention which he had set up. His pencil drawing, though more orthodox in approach, used also a highly characteristic technique for the achievement of tone. 'I'm immensely fond of pencil. I like pencil to hang up in my house. I think there's something wonderful about a pencil drawing. I just draw, and rub it with my finger or anything else, and then fiddle with it – I think "fiddle with it" is the right term – until I get it right. Draw, then start getting tone by your finger, your pencil, indiarubber of course, until it has eased up and you get it right.' (He also used his finger to achieve texture in his paintings.) Lowry's principle pencil work of this period is seen in landscapes of the Fylde countryside – with which, he told Stanley Shaw, he was 'fascinated between 1918 and 1925' – and in line drawings which reflected more sharply his compulsion to register the urban scene. Most of this work was done in his room at Pendlebury in the evenings under artificial light. Much later, as he built up the myth, he declared that he was devoting a thirteen-hour day to his art, 'from ten in the morning until perhaps eleven or twelve at night, without going out of the house very often'. On the occasion of this particular statement, when he was quite innocently asked, for elucidation, whether he was not put out by the absence of natural light, he did in fact visibly falter. His gaze dropped and he hesitated appreciably before saying with some uncertainty, 'No. Yes. Well, I could work just as well at night as I could in the daytime.'

By 1921 Lowry had completed enough work to hazard his first exhibition. He shared space in an architect's studio in Mosley Street, Manchester, with two acquaintances who were water-colourists. The critical response he got from Bernard D. Taylor, the art reviewer of the *Manchester Guardian*, shocked the susceptibilities of the Manchester Academy of Fine Art as much as it delighted Lowry. This notice was published on Monday 31 October 1921, a date never forgotten by Lowry, who quoted it con-

stantly as a personal festival with something of the importance that Trafalgar Day has for the Royal Navy. To reproduce the notice in full gives a just indication of the balance of responsibility accorded by Taylor to the three exhibitors:

In an exhibition of pictures by three Manchester artists, open at 87 Mosley Street, it is refreshing to note in the water-colours of two of the exhibitors, Messrs Tom H. Brown and Rowland Thomasson, evidence of study of some of the masters of water-colour. The gradation of skies in the pictures chosen, the general composition, and the arrangement of light and shade show a real pictorial attempt and not merely a literal transcript from nature. The chief need that appears is for greater distinctiveness in quality of drawing and colour. The third contributor, Mr Laurence S. Lowry, has a very interesting and original outlook. His subjects are Manchester and Lancashire street scenes, interpreted with technical means as yet imperfect, but with real imagination. His portrait of Lancashire is more grimly like than a caricature, because it is done with the intimacy of affection. He emphasises violently everything that industrialism has done to make the aspect of Lancashire more forbidding than that of most other places. Many of us may comfort ourselves a little with contemplating suburban roads, parks, or gardens in public squares, or with the lights and colours of morning or sunset. Mr Lowry has refused all comfortable delusions. He has kept his vision as fresh as if he had come suddenly into the most forbidding part of Hulme or Ancoats under the gloomiest skies after a holiday in France or Italy. His Lancashire is grey, with vast rectangular mills towering over diminutive houses. If there is an open space it is of trodden earth, as grey as the rest of the landscape. The crowds which have this landscape for their background are entirely in keeping with their setting; the incidents in the drama of which they are the characters are also appropriate. 'A Labour Exchange', 'The Entrance for Out-patients', 'A Main Street in a Small Town', 'A Quarrel in a Side Street', 'Ejecting a Tenant' are titles which will give a clue to the subjects of the pictures. We hear a great deal nowadays about recovering the simplicity of vision of the primitives in art. These pictures are authentically primitive, the real thing, not an artificially cultivated likeness to it. The problems of representation are solved not by reference to established conventions but by sheer determination to express what the artist has felt, whether the result is according to the rule or not. The artist's technique is not yet equal to his ideas. If he can learn to express himself with ease and style and at the same time preserve his singleness of outlook he may make a real contribution to art.

No sharper critical insight into Lowry's art was to be printed for thirty years – certainly not in response to his first London show, which itself was eighteen years distant in the future. The review was, of course, an inestimable tonic to Lowry. 'It gave me great confidence to carry on. It

was highly important to me at that time. But the *Guardian* were very wonderful for many years. They were all I had, artistically.'

The news stories of 31 October 1921 have a curiously familiar echo: 'A critical point in the Irish negotiations; how far will Sinn Fein yield for the sake of peace?' 'The Brussels Conference of Powers has laid down that they will not offer credit to the Russian Government to help the starving until the Russian Socialist Federal Soviet Republic recognises the debts of the former Tsarist Government.' In the meantime charitably minded Mancunians laid down a Mile of Pennies for the Russian Famine Fund in Barlow Moor Road. Lowry, however, paid no attention to Barlow Moor Road in southern, residential Manchester, but concentrated on the industrial scene north of the Irwell. It will be recognised that among the paintings in his Mosley Street exhibition was one that was to become a perennial subject with him, *A Quarrel in a Side Street* – confirmed by the drawings *The Quarrel* (1916–18) and *A Quarrel* (1925) and various versions of *A Fight* – and another subject which, because it was part of his daily life, was always fascinating to him but was tactfully toned down in the future: *Ejecting a Tenant*. In his line drawings of this period – totally ignored by collectors for thirty years, and some of them only rescued from extinction by Geoffrey Bennett – he was introducing a subdued note of humour, grim in *The Rent Collector* (1922), juvenile in the legend over the shop in *A Quarrel*.

Lowry's immediate interest after his exhibition of 1921 was the completion of his important picture *A Manufacturing Town* (1922). This is a lively scene in an urban open space where about sixty busy characters dominate, rather than are dominated by, the terrace houses, mills, chimneys, and colliery winding gear which is clearly their unrejected natural habitat. In the middle of the space – a detail which was to become quite common practice – Lowry placed the figure of the observing artist: a quite remarkable physical anticipation of the tall, intent, forward-bending figure who was a quiet onlooker in much later pictures and was photographed in the same stance forty years afterwards.

What is most noticeable about the picture by comparison with the later Lowrys is the darkness of its general tone. The over-riding colour effect of

the painting is of black on brown, with the only contrast at the very top, where the chimneys pour thick smoke into a sky as pale as vomit.

A Manufacturing Town had a history doubly associated with Lowry's *Manchester Guardian* angels. When the newspaper ran a civic week in 1925, they asked Lowry if they could reproduce three of his pictures in the very elaborate issue they brought out for this occasion. One of those which he submitted was this urban scene of 1922. The assistant editor, A. S. Wallace, liked the selection so much that he asked if he could buy one. At that time Lowry was over the moon at the receipt of twenty guineas, and thrilled with Wallace's appreciation he put two into the package for the price of one: it is not clear which Wallace had chosen. 'I threw another one in. It was no loss to me. I wasn't selling them, so there was no sacrifice there.' No one could have deserved that gift better than Wallace, an ornament among the brilliant (but parsimoniously paid) *Guardian* staff in that era of the paper, who was as attractive a writer as he was a man, a quiet Bohemian in that Café Royal of the North the Manchester Press Club, highly knowledgeable and civilised.

Wallace kept the picture until he died, and it eventually came up for sale at Christie's in 1968. Lowry was generally (and understandably) bitter about the prices his pictures were fetching by then, when they were dealers' commodities which brought him no advantage: he had uttered on another occasion the not entirely original remark that his reaction was the same as that of the horse which had won the Grand National and saw the prize being given to the jockey. But in this case he was delighted that the family of his first patron stood to receive some £5,000. 'Mr Wallace enjoyed that picture all his lifetime. I'm very pleased if his family will be helped by the sale. He was a very nice chap, very helpful to me, and giving a picture to him then was no sacrifice. They were bringing nothing, nobody would buy them for years after that. Good luck to his family with it. I'd like them to do well out of it. What I'm interested in about the picture is to see how it has worn. I got a surprising amount of movement in it for that time. If I had it back now I don't think I could do anything in the way of design that would improve it. It is one of my very earliest pictures and it looks to me to be one of my best.'

But a more important artistic consequence of the connection between this picture and the *Manchester Guardian* is that it led to Lowry's significantly changing his style. After Bernard Taylor's constructive criticism in 1921, Lowry used occasionally to consult Taylor. One day he visited Taylor with a picture which may very well have been this one – there is no other surviving specimen which is a better candidate. Lowry was very definite as to the dénouement: 'At first I was painting very black, very dark. Then I was given a shock. I had a picture of an industrial scene that was very darkly painted. I took it to Taylor of the *Guardian* who was a very good friend to me in those days. He said, "That's no good at all, you know, no good at all." "Why?" I said. I was very annoyed with him. "Well," he said, "look at it." And he held it up against the wall, which was darkly coloured as they were in those days, and my picture was black. He said, "You'll have to paint your pictures so that they stand out against the wall even if they are industrial scenes." "How do I do that?" I asked. He said, "That's your affair, not mine." I was very angry with him, very cross indeed. But I went away and I painted a couple of figures on a pure white background and I took them to him. "That's what I meant," he said, "that's the thing to do." And he was right.'

From that time on, Lowry painted almost all his industrial landscapes on a basically white background, and this is the salient feature of his later works. It is not entirely accurate to say that he had never done this before. His picture *Sudden Illness* (1920) is painted against a beige-pink background which is none the less hellish in the context of the dark Satanic mill in the middle distance. The definitive contrast to *A Manufacturing Town* is the Manchester City Art Gallery's *An Accident* (1926), which places the human figures against a light ground, not against the sky, and established Lowry's convention in this field of painting; but he arbitrarily breaks this rule in a pastel such as *Outside the Mill* (1930).

Yet in another feature all the pictures in Lowry's work observe a separate tradition that he had already instituted: he never painted shadows. This was something that Bernard Taylor could never argue him out of. 'I've a one-track mind,' Lowry said jocularly much later. 'I only deal with poverty. Always with gloom. You'll never see a joyous picture of mine. I

never do a jolly picture. You never see the sun in my work. That's because I can't paint shadows. I kept trying for years. Bernard Taylor said to me, "These pictures have no shadows, you ought to put shadows in." I tried. But I simply couldn't put the shadows in. So I said "Blow it" and I went on without shadows after that. I decided to be entirely false. All my pictures are false, without shadows.' Lowry gave many different versions in his time regarding this absence of shadows: 'They spoil my design.' 'They add nothing to the picture.' Critics have interpreted the idiosyncrasy as a clear indication that he was used to painting only in artificial light – but this conclusion is difficult to justify. The trait can only be accepted as an obstinate man's idiosyncratic rule, which his own attempts at rationalisation in no way explain. Similarly, Lowry declared at the age of eighty: 'I can't do a cat yet. The only way I can do a cat is by doing a very bad dog and then in a way decapitating it, and it becomes a cat.' But the unmistakable feline observer in *The Cat Looks On* is a far more recognisable animal object than the reconstituted sausages which Lowry, in some strange idiom, consistently used for dogs: and there must be a thousand Lowry dogs on canvas now against that one quite exquisitely observed cat.

One additional fact relevant to Lowry's avoidance of shadows is that, all through his life, he never enjoyed going out into the sun. 'I can't stand the sun,' he declared. And although, increasingly with age, he moaned at the rain and gloom of the North, that overcast North of England was something he could not leave. Except for brief visits to Glasgow he never left England and Wales. Taylor's imagination was wrong when he pictured Lowry observing industrial Lancashire with the fresh eyes of a man who had just returned from France and Italy. The Mediterranean was not this man's hunting ground.

In continued fascination with the use of white as his base, Lowry began to experiment. He wanted to see how the white would wear down in time. In 1924 he painted a piece of board with flake white six times in succession. After it was dry he had the board sealed, getting a man at the framer's to seal it as professionally as possible. He did not touch the board for seven years. Then he opened the seals and compared the colour with a newly-painted board. Against the dead white of the new paint the old

board had gone down to a creamy grey. That, Lowry decided, was what he wanted. He thereupon began to paint his pictures with an adjusted eye to how the colour would come out at a later time. He lived quite long enough to see that, if he was working for posterity, his method was fundamentally right. But he never explained the sealing. A true seal would delay the weathering of time. A board sealed for seven years might register only two years' normal toning down.

Naturally he did not wait for the first seven years to elapse; he had the confidence to proceed according to his theory, and he was satisfied with the result. He normally filled his canvas on the first day of work on it, though many pictures were not laid aside until perhaps two years after the start. 'I painted a canvas white, sometimes painted it twice, then let it dry. Then I started with the whole picture, limning it in the first day. After that, the job was to complete it inch by inch, going over the whole picture every day, but I would have got it all in on the first day. I worked on it and worked on it until I decided it was finished. I could never say outright that it was finished until I had put it away, and picked it out after a time, and said, "Well, there's nothing more you can do with that."

'After I had been convinced by Taylor, I knew that my first job was to get those figures standing out from the background. The interest of the picture was in the figures, and so I had to keep the background artificially white because the picture was worthless if the ground and the figures merged. I knew that the white could be relied on to drop a little, but white could never be lifted up. As I got more experienced I knew how my chalky white would come down to cream in ten years. But my job in the early days – and it *was* a job – was to paint those figures, paint them as well as I knew how from all my work in the life class. I was fairly confident as to how the background would go. The chalk-white backgrounds don't go down and down. After a few years they settle. They drop a certain amount and then they stay.'

In 1924 Lowry had a serious aberration from the pattern of his normal life. This materialised as a strange yearning for a contemporary machine. He told Robert Robinson: 'I was very bothered about a car in 1924. "Mother," I said, "if you'll buy a car I'll drive you out." But she didn't

take to the idea. Oh, no, not at all. "We'll wait till your father comes in."
When Father came home he just said three words: "The man's mad!"
It bothered me at the time, but I don't think I should have made a driver.
No, I don't think I should.' Significantly, it was his mother rather than his
father who, he proposed, should buy the car. Hers was the moneyed side
of the family. His father was sixty-seven years old at the time.

The momentary impulse highlights the extraordinary fact that it is very
difficult to find a Lowry picture with a clearly identifiable representation
of a motor car in it, though the internal combustion engine had been
developed at the time when he was born. It was not that motor cars, buses,
or lorries were rare, nor that they were particularly lacking in picturesque
qualities. Adolphe Valette included both horse-cabs and black-and-yellow
motor taxis in his 1910 impressionistic paintings of Albert Square and
Oxford Road, Manchester, and gave the newer machines considerable
form, even grace. It was not that Lowry had an abhorrence for wheeled
traffic. He painted horse-carts, hand-carts, invalid carriages, perambulators,
bicycles, trolleys, cripples' wheeled platforms, and even a portable barrel
organ. He also extended his artistic hospitality to trains and ships. He may
have had a deep grudge against the motor car, though it is true that he told
Noël Barber in 1963: 'I've started painting the backs of old taxis. Isn't
that ridiculous? I mean the back, not the front. I've done a lot of taxi backs
now. People say they look like hearses, but I don't think so. I can't help it.
Nobody buys this sort of thing. Still, I go on doing them. A year ago it
was chimneys. Tall black chimneys on white background. Nothing else.
People didn't buy chimneys either. They only want little people. It's all a
bit odd, isn't it? There's no accounting for tastes. Specially mine.'*

It is indeed unlikely that anyone bought his paintings of the backs of
taxis, if indeed they were taxis, and he was not all the time referring to
horse-cabs. By a wilful twist of the imagination the pencil drawing *The
Cab* (1960) may be interpreted as an early motor vehicle rather than a
growler, but for little other reason than that there is no sign of the horse's
hooves.

* Noël Barber, *Conversations with Painters*, 1964.

Lowry once referred to an occasion in 1943 when he asked his house-keeper how he could improve a painting of wartime Britain commissioned from him by the Government (regarding the design of his pictures, Lowry much preferred the advice of amateurs rather than anyone who knew anything about painting). 'I said, "Come here, Ellen, what's the matter with this picture?" Now she was a person who knew nothing about art and cared still less. "Oh," she said, "you want to put a bus in it, a red bus." "Now where shall I put the bus?" "Oh, put it there" – and she named the right place. So I put the bus in. It was a little better, but not quite right. I said, "Ellen, you and your buses, I've put a bus in as you said, and it's no better." "It *is* better," she said. "Well," I said, "what does it need now?" "It needs another bus just behind it." So I put it in, and it did it. But I said to her, "Look, I've put two buses in and I think it's no better than it was before." She said, "If you touch it again you'll spoil it." And looking back, I feel that she was right.'

Finally, it may be noted that when the Queen bought a Lowry picture from the Royal Academy Summer Exhibition of 1963 (she had purchased others before), and after the show sent to the Academy for it to be hung in Buckingham Palace, the subject was briefly and accurately described as *A Carriage*. The vehicle is completely closed. Lowry used to say that he himself was inside it. That was one way to go, unembarrassed, into Buckingham Palace.

In 1925 he was asked to exhibit with the Manchester Society of Modern Painters, and under the aegis of this society he put his work into a number of local exhibitions held at the Manchester City Art Gallery during the next five years. An important work of this period is his *Self-Portrait* (1925). There seems authentic character emerging from what is a surprisingly young face for a man of thirty-seven. He certainly did not aim at preten-sion, and painted himself in the Manchester uniform cap and raincoat. Lowry always considered it a very good likeness. 'I had a great tussle with it, and when it was done I said "Never again, thank you." I think it was very good when I did it, but it was damaged by damp and after twenty years I sent it to the restorer's. He did what he could but he apologised for not having done more. The colours have gone.'

As part of his training Lowry had gone, on Valette's advice, to study with William Fitz, an American portrait painter living in Rusholme. 'Billy Fitz was very good in making research on the forms of anything. You had to search for the forms, and then work on that. They looked as if they were cut out of paper. It did me a lot of good. He was a competent painter, but I don't think he was very distinguished. That doesn't matter. A teacher doesn't need to be distinguished.'

At this time, and for a year or two before, Lowry had pursued as a promising subject the urban calamities that put drama into the street scene. 'I was doing accidents,' he said, 'from about 1923. Accidents interest me – I've a very queer mind, you know. What fascinates me is the people they attract, the patterns those people form, and the atmosphere of tension when something has happened.' He had, in fact, been exploring tension as early as 1916 with his drawing *The Quarrel*. 'Where there's a quarrel there's always a crowd,' he told Monty Bloom. 'It's a great draw. A quarrel or a body.'

In 1926 he painted *An Accident*, which is now in the Manchester City Art Gallery. It was based on his recollection of the recovery from a Pendlebury canal of the body of a woman who had committed suicide. 'A large crowd seemed to come absolutely from nowhere in no time. The incident rather got hold of me,' he recalled. It might be conjectured that at times suicide tempted a man of his occasionally gloomy temperament. 'I can understand the feelings of people who commit suicide,' he admitted. 'Life can get too much for you. You feel, "What is it at the end?" There is no loss, you're only hastening the end, why not commit suicide.' But he recovered himself with his usual defence of jocularity. 'Mind you, I don't think I've ever actually done it, you know!'

Lowry developed his interest in calamities with his painting *The Funeral* (1928). A sombre and striking composition, it is not the only representation of a funeral which he did, but along with his *Funeral Party* it is the most serious. The Royal Academy knew about his funeral pictures, but when they were preparing for their Retrospective Exhibition of 1976 they could not trace one. Lowry was still alive while the early arrangements were being made, and they asked him if he had done another work like

The Funeral. He replied, 'You can only do your own funeral once, sir.' In truth, he had done it a number of times and talked about it even more. He could describe the pictures, though he did not know where they were. In one version the undertaker was laughing uproariously. Lowry declared in 1963: 'I would really like to see my own funeral and paint it. I don't think anyone would turn up. About forty years ago I painted a picture of what I thought my funeral would be like. The hearse was a beautiful job drawn by horses, and the undertaker was smoking a fat cigar to celebrate the order. It disappeared mysteriously some time ago.' On another occasion he described what may have been a different picture or an elaboration of the same: 'I did one or two funerals. I did one of my own funeral a long time ago. A splendid hearse. High-stepping horses. Inside the hearse was a coffin, and there was an enormous lot of flowers on top of that coffin. Oh, it was a magnificent wreath. And the only man inside was the undertaker. He'd provided the wreath. Because he'd get a commission on it, you see. And there was nobody else at the funeral.'

All through his life Lowry was talking of his own funeral, and increasingly towards the end. 'Oh, I'd like to be at my own funeral. Of course, I shall be there, in a passive capacity. I shall be the man in the hearse. Crowds? No! One man in the coffin and a solicitor in the coach. And the solicitor will be saying, "Now, let me see, if I can get away now I can catch my two-thirty." Well, why shouldn't he catch his two-thirty? And the man from the registrar's office comes along to meet the undertaker, and he says, "It's a cold day, isn't it?" and they agree it's a cold day, and I'm not bothered. In my wooden cot it doesn't matter if it's a cold day or not.'

From about 1926 there was a change in Lowry's style which the critics noticed, if only in retrospect (it was to be another thirty years before the pundits considered him sufficiently important to classify his 'periods'). Reviewing the Retrospective Exhibition at the Manchester City Art Gallery in 1959, the *Times* art critic said: 'From the mid-twenties a slight touch of the grotesque crept into the individual figures; and an elderly commentator cannot help observing that the characteristic Lowry man – clumsy, bulbous boots, spindly legs, short coat with widish skirts, little

stick, bowler hat (or cap) jammed well down to his ears – is extraordin-
arily like the artful simpleton presented on the music halls by the greatest
of all Lancashire comedians, the elder George Formby.'

On the same occasion Eric Newton in the *Guardian* described Lowry's
world as 'peopled with a race of sub-human black-and-grey beings and a
sprinkling of sub-canine pets'.

Lowry himself could see the point that was being made, but he did not
accept any label of grotesquerie. He knew that he had changed, knew that
he had no intention to caricature, and puzzled over the question without
accepting the critics' implication. 'Those figures are in no way my short-
hand symbols for people,' he said. 'They are intended by me to be people
as I actually did see them on a particular croft. I saw in my mind an actual
place full of people and I tried to set them down. While I was painting I
tried to do those figures as well as I could. There was no thought of
making designs or ghosts out of them. I was trying all the time to make
them as real as I possibly could. If they have not seemed to come out that
way, blame my make-up. I know it's a puzzle and I have often thought
about it. I couldn't have done those little figures without my academic
training. In my own opinion I owe everything to the drawing I used to do
at the art school, first the antique drawing and then the life.'

He made the same claim to Edwin Mullins: 'To begin with I did a lot of
studies of little figures, drawing them as well as I could. I didn't know
they had big feet until people told me. I was doing the industrial scene as I
saw it. And the figures got better with practice. They got movement.'

Artists are not always the most perceptive critics, even of themselves.
Sometimes, as they tell stories or expound theories through the years,
there is a slide of truth as one belief merges into its successor. 'I didn't
know they had big feet until people told me' was a remark going back
only twenty years, to 1946, not forty as Lowry was implying to Mullins. It
echoes an occasion historic in Manchester art circles when Maxwell Reekie,
the not too subtle President of the Manchester Academy of Fine Arts,
which had been so derogatory to Lowry a generation previously, boomed
out at Lowry during the private view of a post-war exhibition, 'But look,
Lowry! The feet are far too big!' Lowry believed that his figures had got

better with practice, and had acquired *movement*. When he said that, he had not seen for forty years the painting *A Manufacturing Town*, in which the lively figures are much less conventional than Lowry's 'little men' afterwards became. When he finally did see it, when the picture came up for auction, he was extremely surprised at the *movement* he had been able to register in 1922.

Whatever the motive or trend which influenced the realism of the 'little men' around 1926, Lowry had by that time firmly established his technical method of preparing a chalk-white background which would mellow with time, and his refusal to tamper with the texture of the colours he used. This rule lasted through his life. 'I use no oil or medium of any sort. I use the Winsor & Newton colours and put them on – I mix them, of course. I use no medium whatever and I never "oil out". I just work on the picture as it is.' When the Manchester City Art Gallery bought *An Accident* in 1930 Lowry wrote to the Director: 'About the paint – It was done on wood on a white ground – laid in solidly at one shot – then the roughness scraped off and the whole gradually worked up in detail to the end. No oil used, or varnish – I do not use either. Have not varnished a picture for a long time. I somehow prefer not to.' When later the Gallery bought *An Organ Grinder* (1934) he wrote: 'The first painting is laid on solidly on to a white ground, and then worked up to a finish by degrees... Don't varnish, please.'

By the late twenties Lowry, for all his humdrum daily occupation, had a comparatively busy public life, exhibiting with the Royal Institute of Oil Painters (R.O.I.), the New English Art Club, and the Manchester Society of Modern Painters, and in Paris. He was not a man of no account.

In appearance he was neither down at heel nor Bohemian – at least when he took a woman out. His cousin Grace Shepherd worked at the Westminster Bank in York Street, Manchester, and he used to call to take her to lunch every Friday. Geoffrey Bennett, who first met Lowry in 1926 through Grace Shepherd, remembers him then as a tall, slender man of thirty-eight who was smartly dressed.

Besides his paintings of creative imagination he was executing at this time a number of drawings which were careful records of Salford, finely

done and invaluable today. They include *By the County Court, Salford* (1926), *Dwellings, Ordsall Lane, Salford* (1927) – the painting made from which is now in the Tate Gallery – and a number of very attractive studies of Peel Park. There were also some exquisite line drawings capturing the life of the streets, the figures highly realistic save for the large Lowry feet, as in *The Midday Special* (1926). For the drawings of factual record his sketching was far more methodical than in the sketches he used to make on the backs of envelopes when he was jotting down a spontaneous human activity which he had come across during his constant perambulation of the streets. 'I would stand for hours on one spot,' he recalled, 'and scores of little kids who hadn't had a wash for weeks would come and stand round me.'

By 1928 Lowry was exhibiting in Paris, at the Salon d'Automne and with the Artistes Français. He submitted the quota allowed, two a year to the Salon d'Automne, and he was never rejected – a fact which he would gleefully emphasise, both at the time and throughout his life. In his opinion, often repeated, he was scoring a triumph over the Manchester art establishment which had previously rejected him. The record indicates, however, that he was being shown with fair regularity through the late twenties.

It is true that no one was buying his work – but that was also the case with the pictures shown in France. In November 1930 Lowry showed at the Salon d'Automne *Coming from the Mill* (1930) and *A Hawker's Cart* (1929). Both of them duly came back to James Bourlet, who dispatched and stored Lowry's work, and the first is now at Salford, the second in the Royal Scottish Academy. In November 1929 Lowry showed *Lodging Houses*, which is now untraced, and *A Removal* (1928), which certainly came back to Great Britain, was shown in Manchester in 1933, and was eventually acquired for an English collection. Geoffrey Bennett saw this picture and asked Lowry: 'Why do you call it *A Removal*? It is an eject-ment.' And indeed in the picture the bailiffs are bringing out furniture and piling it outside a house with no sign of any removal van or hand-cart – a circumstance with which rent collector Lowry, as the representative of the property company summoning the bailiffs, must have been very familiar.

Lowry said to Bennett, 'You're right. But I didn't think people would like the title if I called it *An Ejectment*.' He had not been so squeamish earlier, for he had entitled one of his pictures exhibited in 1921 *Ejecting a Tenant*, and his drawing *The Rent Collector* dates from 1922. Possibly he had decided to improve his image.

Lowry's habit of going back to fruitful subjects again and again is illustrated by the interval between *Ejecting a Tenant* of 1921 and *A Removal* of 1928. *Lodging Houses*, his other subject in the Salon d'Automne in 1929, crops up under the title *Outside the Lodging House* as a pencil drawing dated 1938 and now in the Manchester City Art Gallery, which is also uncannily similar to *The Fight* (1935). But as a possible indication that Lowry did go back to the scene of his incidents, did update his records, it is interesting to note that in the 1935 picture the lodging house beds are priced on the window at fourpence and sixpence per night, but in 1938 rising prosperity has increased the rate to ninepence all round.

Lowry stopped sending to Paris when he grew increasingly worried and unproductive as a result of his mother's last, long illness. He never, of course, left the shores of England to go to Paris. He said of the venture: 'The Salon d'Automne was a very good show in those days. And, contrariwise to everyone's expectations, I got in. I sent two pictures to each show for five, maybe seven years. [He had in fact finished by 1933.] And I got in, every time, and got well hung, and had some good notices. That made me feel that there was definitely something in what I was doing. For I had no advantages, and I was being judged entirely in merit. They didn't know me from Adam, I was an Englishman showing in France, and they're not partial to an Englishman showing in France. Then things got difficult at home with my mother. I didn't do any work for a time, and I suddenly ceased to send. But that was the time when I did begin to feel some confidence, since everything I sent got in.'

A French dealer, impressed by what he had seen at Lowry's first Paris showing in 1927, wrote offering to take Lowry up and operate for him in Europe. He said that it would be some weeks before he got in touch again but that Lowry would be hearing from him. Lowry received no further communication on this matter. He was bitterly disappointed. Many years

PLATE XVII Lowry's easel, now in the Salford Art Gallery.
ROBERT MCWILLIAM

PLATE XVIII Lowry at The Elms with his close friend the late Leo Solomon, then Principal of the Rochdale College of Art, 1975.

PLATE XIX The critic and art dealer Mervyn Levy with L. S. Lowry, 1975.

PLATE XX The Elms, Stalybridge Road, Mottram-in-Longdendale – Lowry's home from 1948 until his death.
ROBERT MCWILLIAM

PLATE XXI The back door of The Elms.
ROBERT MCWILLIAM

PLATE XXII Mrs Lowry at a reception at Salford Art Gallery, November 1975.

PLATE XXIII Mrs Lowry with L. S. Lowry, Salford Art Gallery, November 1975.

PLATE XXIV L. S. Lowry arriving at Salford Art Gallery, November 1975.

later he mentioned the name of the dealer and the fact that he had approached him to a man who was conversant with the European market. 'Yes, wasn't it sad!' said Lowry's companion. Lowry ventured the opinion that it was more than sad, it was a dirty trick. 'But didn't you know?' said the man. 'He died. He was going into hospital for an operation – that must have been the time he wrote to you – and he never came out again.' Recounting the story much later, Lowry added, 'Since then I've never judged a man for not answering his letters.' But that was far less a charitable gesture to the dead than a self-defensive sentiment inspired by the enormous number of letters which lay in fine china bowls and spilled on to the table in his own house: letters which he had never even opened. 'Never do today what you can put off till tomorrow' was one of Lowry's mottoes as he got older. Indeed, it eventually became necessary to send him a telegram to advise him to open an approaching letter with the sender's name on the flap.

The only Briton exhibiting at the Salon d'Automne with Lowry who is still considered notable today was Sir John Lavery, then over seventy and a tardy Royal Academician since 1921, when he was sixty-four. But even Lavery did not get into a European Painters Who's Who into which Lowry was inducted in 1931. This was Edouard-Joseph's *Dictionnaire Biographique des Artistes Contemporains 1910–1930*, published in three volumes in Paris by Art & Edition in 1931. Lowry treasured this directory all his life. A few pages away from him were the entries for Maillol, Manet, and Matisse. (Oddly, there is no mention of Magritte, who was in Paris from 1927 to 1930, the three most important years for surrealism then.) Lowry, Laurence-Stéphane, was listed as 'élève de l'Ecole des Beaux-Arts de Manchester puis de Salford' and was described as a specialist in oil paintings and drawings of industrial street scenes. His Paris exhibitions were named, and it was mentioned, in 1931, that his picture *Coming Art of School* (*sic*) had been bought by the Tate Gallery, an early acquisition which has not been recorded in his biographical chronology at his many exhibitions, even for the last great visual obituary at the Royal Academy. Indeed, Lowry never mentioned it himself. Yet the work is at the Tate, it was shown at the Royal Academy in 1976 under its correct title *Coming*

Out of School (1927), and was illustrated in the catalogue. It is astonishing that Lowry had been bought by the Tate before he had even exhibited at the Royal Academy. He remedied this omission in 1932, but put in only one other picture over the twenty-three years until 1955, when he accepted the invitation to become an Associate.

The *Dictionnaire Biographique* carried alongside Lowry's entry two reproductions of his work. One was *A Town Square*, with the attribution 'Salon de 1928'. The other was Lowry's *Self-Portrait* of 1925. It is well reproduced and, even in monochrome, shows a remarkably fine quality in the painting which is not so clear today. The damage from damp which Lowry complained of must indeed have been serious.

In 1930 Lowry was commissioned by Harold W. Timperley, an old acquaintance from the life class of the Manchester School of Art, to illustrate Timperley's own manuscript *A Cotswold Book*. He made a number of pencil drawings for the book, which was published in 1931. The originals were privately acquired by Lowry's friend A. (Ted) Frape, the Director of the Salford Art Gallery, who built up Salford's collection of Lowrys to become by far the most important in the country.

Also in 1930 Lowry had a one-man show – for one day – at the Round House, the Manchester University Settlement in Every Street amid the Ancoats slums, which was then strongly under the influence of Professor J. L. Stocks. Stocks and his wife Mary, now Baroness Stocks, were intelligent and influential social-realist do-gooders of the most admirable type – though not Lowry's cup of tea. Using the unknown, ought-to-be-known artist Lowry to swell the cultural prestige of the Round House among its prosperous Quakerish sponsors, and to give poor old Lowry a leg-up at the same time as passing round the hat for the soup kitchen, was a characteristic stroke of Stockism. The principal exhibits were a series of pencil drawings of Ancoats which were records of Manchester as memorable as the previous ones of Salford. In the end the wealthy Miss Margaret Pilkington of the industrial glass family, and the influential Manchester magnate A. P. Simon, who had an option on all culture in the city from ballet to brass-rubbing, bought most of the display.

This upset the Director of the Manchester City Art Gallery, Laurence

Haward, who had been tipped off by the enthusiastic Stocks but had made the short tram-ride into the unknown territory of Ancoats a day late, and found the cream of the collection at the Round House lapped up. Haward was familiar with Lowry, who had exhibited many times in local shows mounted at the City Art Gallery, but his tone in communicating with Lowry seems always patronising and condescending. He wrote a few days after the exhibition: 'I find that most of the drawings which I wanted to submit to my Committee had already been purchased when I came up the next day, but I have persuaded Miss Pilkington to offer the Rutherston Collection your drawing of "Stony Brow" which she had ear-marked.' Miss Pilkington in fact had no time to gloat over *Stony Brow*, for it was consigned to the Art Gallery within days: the first acquisition by Manchester of a work by Lowry, and tying with the Tate Gallery for the first public acquisition anywhere.

Haward continued his letter to Lowry – appropriately dated 1 April 1930: 'Meantime I wonder if you will consider my suggestion that you should at your leisure make one or two studies of Piccadilly as it is today with the sunk garden, the loafers, the ruins, and all the rest of the mess and muddle. We cannot of course commit ourselves in any way, as I explained to you the other day, but I think that if you can put down some of your impressions of this hub of Manchester life it would be worth your while to submit them eventually to my Committee with a view to possible purchase.'

This entirely characteristic letter from a city bureaucrat trying to get art without brass received the calculated amiable response from Lowry, and some three months later he showed Haward a portfolio of what he had done. Lowry had made the mistake of taking his non-binding commission literally. He had drawn the loafers, the ruins, the mess and muddle, as requested. The work was returned. Haward wrote with some distaste that Lowry's drawings were 'very interesting examples of human beings, very interesting in so far as they give glimpses of the kind of people who are to be found on the site today'. But he now asked for a general view of this quite vast area such as 'you would get from a first floor window of Lyon's Popular Café.'

Lowry excused himself from this second attempt to get artwork sub-
mitted on approval without commitment – which did not seem to a
Manchester man, well pickled in the conventions of that city, so demean-
ing as it might have done at the Salon d'Automne in Paris. Lowry was
being treated exactly like the legion of talented but hungry free-lance
designers who catered for the then virtual monopoly of the cotton printers
in putting out coloured patterns to suit the tastes of Wigan, Winnipeg, or
West Africa.

Meanwhile Haward was negotiating to buy *The Accident* (1926). Its
price was thirty guineas. In his defence and on behalf of the Manchester
Corporation Treasury it must be said that the picture was four years old
and getting quite dusty, nobody had bought it at thirty guineas, times
could be shown – they could always be shown – to be harder now than
then, it was an honour for the Art Gallery to approach Lowry and some
people would even pay for the prestige, and Lowry was a soft touch any-
way. Lowry certainly justified the final description. He wrote on 18 Sep-
tember 1930: 'I would like to get twenty-one pounds for this, but do not
want a pound or two to stand in the way of a Sale.' Never was a clearer
signal offered that the artist would let his work go for half the original
price.

This sale aroused a fleeting spark of interest in the mind of Lowry's
father, who had shown a deadening lack of enthusiasm for his son's work
over what was now half a mature lifetime of constant application. Lowry
often recalled: 'My father would look at an odd picture of mine and say,
"Ee, you're a rum 'un. I can't see you selling anything." That was not so
bad as the attitude of the rest of my relations. I was a laughing stock to
them. My mother and father – my mother particularly – were at least
sympathetic. But the family were very good. They said, "He can't help it,
you know. It keeps him out of mischief, he's not fit to do anything else."
So I went on painting pictures. When I sold one there was hysteria in the
house. My father used to get in a terrible state. He used to go up the walls,
and say "Good gracious, what next!" I remember one March when I had
not sold anything for a long time, and a neighbour's daughter came into
the house. She bought two drawings for seven and sixpence each. Six

months later I sold a little oil painting for three guineas. My father turned to my mother and said, "This simply must not go on. If this keeps up it will be going to the lad's head. We can't have him swelled-headed." This was after selling three pictures in six months for three pounds eighteen shillings.'

Robert Lowry sired one picture, *St Simon's Church* (1928), of which Lowry said: 'I think it's one of my best pictures. My father wasn't interested in my work, but he said to me one day, "There's a church in Salford, at the top, St Simon's, you ought to go and see it, it's your cup of tea. Up your street." So I didn't do it. Naturally. Never do today what you can put off till tomorrow. I never do what I'm asked to do at first. And then he said, "You'll really have to go and see that St Simon's Church. It's your cup of tea and it's going to come down very soon." So I went up and made a drawing, and went again in another month's time to check up on it, and it had gone absolutely flat. The only time my father was ever interested in my art.'

Lowry's father did also respond once to his son's technical experiment with the painting and sealing of the board which he had covered with six coats of white paint. In 1931, after seven years, Lowry unsealed the board and found the creamy grey-white which he knew he was seeking. 'That was the only other time when my father showed interest in my work.' Robert Lowry was at that time old, weak, and idle, and the next winter he shuffled off. He died at the age of seventy-four in February 1932. His will had not been touched since he signed it after his marriage. He left to his wife his sole possessions, which were valued at £534. 4s. 5d. Mrs Lowry immediately drafted a will leaving everything to her son, Laurence Stephen Lowry, property company's cashier.

If Lowry, as he later maintained, was dependent on his family for maintenance, he would have starved during the 1930s. His father's estate was worth less than two years' salary, at the rate which the painter was then earning at the Pall Mall Property Company. Long afterwards, when he was in his eighties and had successfully covered up the fact of his former employment, which was well known in Manchester during the 1930s, he indicated that he had got by on an inheritance of £200 a year and that

this was sufficient for his needs. 'I was an only child, living at home, I hadn't any competence to do anything, I could never pass exams, I never saw my name in a list for passing an exam, I was always among the absent friends. Two hundred pounds a year was a lot of money in those days. You could furnish a house and live comfortably on two hundred a year. I was never married, of course, never engaged, never smoked, never drank. I just drifted on in a dull sort of way. And when things were desperate and I said, "Well this is positively absurd" – I'd have a good sale. It looked to me as if something was happening to keep me going. Just at the right time. It doesn't take much to keep a man going who's on the verge of stopping but who's infatuated with his subject. I had one or two very good sales in those days, one a year, say. One sale a year then was worth far more than one sale a year today.'

Meanwhile Lowry exhibited at the Royal Academy. He also made a surprising return to the Manchester Academy of Fine Arts, and exhibited there almost continuously for the next forty years. He went on to exhibit at the Royal Society of British Artists and was elected a member of that society in 1934. He showed at Salford in 1934 and 1935 and exhibited six pictures in a mixed exhibition at the Arlington Galleries in London in 1936.

In the 1930s Lowry's friendship with Geoffrey Bennett and his wife, Alice, deepened. Bennett was a bank clerk acquaintance of Lowry's cousin when Lowry first met him, and the friendship was consolidated when Bennett, who had moved to Knutsford in Cheshire, was married and set up house in 1933. He and his wife decided that they would like to adorn their new home with one of Lowry's pictures. They approached Lowry and he asked them what they would like. They had seen *A Removal*, still not taken after its 1929 exhibition in Paris, on show at the Manchester Academy that year. It was on this occasion that, as we have seen, Bennett asked why it was not called *An Ejectment*. (Bennett had no idea, either then or at any time during Lowry's life, that Lowry was connected with property estate management or had any regular job at all. This is extra-ordinary in view of the various newspaper references to it, which Bennett must have missed.) The price of *A Removal* was thirty pounds. 'Well,'

reminisced Lowry's friend – now the Reverend Geoffrey S. Bennett of Carlisle – 'we'd no thirty pounds to pay. That was a lot of money in those days, and we had our commitments after getting married. Lowry asked me if I would make an offer for the picture. Well, we just wouldn't because we didn't want to hurt his feelings and offer, say, ten or fifteen pounds. We didn't know what his reaction would be. So he said, "How much d'you want to give?" I said, "I don't think we can afford more than five pounds." "That's all right," he said. "I'll paint you a picture for five pounds." This appalled me and I asked, "Haven't you got one at home that you've already done?" "No," he said, "we can't carry on like that. You must say what you want." Now I had seen a picture that the Manchester Corporation have now. It's called *The Organ Grinder*. I said, "I'd like a street, and I'd want a barrel organ, and a lot of people and a mill and some dogs." "Right," he said. I think he was some six months doing it. But he brought it, and he had put in everything I had mentioned.'

As a comparative note about Lowry's prices, two other occasions may be mentioned. Lowry told a story about one of his first major sales, which he put at about 1926. 'I used to show at the Royal Institute of Oil Painters, R.O.I. One day I got a letter:

EXHIBIT 248

> *Sir,*
> *If your exhibit as above is unsold at the*
> *close of this show I am willing to buy it.*
> *Yours faithfully,*

But I simply could not read the signature, it was illegible to me. The address was quite clear, somewhere in Lincoln's Inn. I hadn't sold a picture for three years and I badly needed to make that sale. I was advised to trace the scrawl as accurately as possible on to an envelope and send it off to the address. I copied the signature as best I could and signified my acceptance. The price was £21 for a 20 by 16. When I next saw Bourlet's they told me that Ackermann's had collected the picture for a client of theirs. But Ackermann's had stressed that no acknowledgement was required. Since they did not give the name of the client and I was forbidden to ask for an

acknowledgement, I did not know and never knew who had bought the picture. But the most magnificent part of it was that the price was £21 and Ackermann's sent a cheque for £36. 15s. Now that was a delightful windfall. And if there was a mistake, I was denied the chance to correct it.' Another of Lowry's pictures, painted in 1920, was originally priced at fifteen guineas. It was not sold for forty years. A collector bought it in 1960 and, although the value of money was different and Lowry's reputation was beginning to boom, the picture was acquired for £100. Some years before Lowry's death the collector decided to sell the picture. It brought in £4,000. Three days after the sale the collector was convinced that he could not live without it, and he asked the dealer if he could have it back. The price he had to pay for his own picture, after a three-day interval, was £6,000 because that was what the dealer assured him he could get for it.

As for the picture with the barrel organ, Mr Bennett has it still. As has been noted earlier, it was not unusual for Lowry to repeat a subject. The first version is *The Organ Grinder*, dated 1934, and it is now in the Manchester City Art Gallery.

In 1933 the *Manchester Evening News*, the sister paper of the *Manchester Guardian*, blew the gaff on Lowry. It revealed quite innocently that he was a respectable city gentleman who painted in the evenings as a relaxation after a hard day at the office. The newspaper stated, on 7 June 1933:

Fame in a night, so to speak, has come to a narrow old street in Stockport, and to Swinton Market Place.

Familiar to the people of Manchester and district, their attractions are now broadcast on canvas throughout Scotland, and through the medium of the Royal Academy.

A Pendlebury artist has done two paintings, one he calls 'A Street in Stockport' and the other 'A Procession' and these works are at present hung in the Royal Scottish Academy, Edinburgh. They have already been exhibited at the Royal Academy, and have been accorded praise by some of the best-known painters of the day.

These paintings, which were done in oils, are the work of Mr L. S. Lowry, of Station Road, Pendlebury. Mr Lowry is the assistant secretary to a well-known Manchester firm of property and estate agents, and he does much of his work in the evenings.

'I work spasmodically,' he said. 'I never pack my canvas and oils and decide to spend a fortnight's holiday painting rural scenes. This is because I believe myself to be subject to

certain moods, and only when the mood for painting is on me do I decide to take my canvas and choose a scene. Even then I confine myself strictly to industrial surroundings – mill scenes, canals, streets – I long ago decided to drop my landscape efforts.'

Much of Mr Lowry's work is better known on the Continent. He has been a regular exhibitor during the last four or five years at the Paris Salon and the Salon d'Automne, two of the best-known exhibitions in the world of art. One of his pictures, sold to the Manchester City Art Gallery, is described as 'The Accident', and depicts a Lancashire mill with a crowd of workpeople standing on a croft opposite the factory gates. Something has happened to one of their workmates and they are clustered round him in eager curiosity.

'A Street in Stockport' is a painting of Crowther-street, a narrow, tortuous, cobbled street with steps leading up to the ancient houses, and handrails running along the stone balconies.

'I got the idea of "A Procession" from Swinton Market Place,' he said, 'during a Whit Thursday procession.'

Mr Lowry says that the greater part of his work is exhibited at the Paris Exhibitions where there appears to be a greater demand for his class of work.

He studied art at the Manchester School of Art. In addition to Continental exhibitions Mr Lowry has had his paintings hung in the New English Art Club, the Royal Hibernian, the Canadian National Exhibition, and a number of the principal provincial art galleries.

Art to Mr Lowry is the antidote to a day of strain at a city desk.

Crowther Street in Stockport, with its broad steps, was one of Lowry's favourite subjects, and he made a number of studies of it. (Lowry liked to paint flights of steps; indeed, there are enough of them in his work to satiate the most zealously Freudian psycho-analyst.) *A Procession* is one of the many pictures showing the crowds who gathered in Manchester and Lancashire for the annual religious Whit Walks during Whit Week. He would never take a holiday if it meant that he would miss the Whit Walks.

Lowry was now entering a period of great emotional stress. His mother was fast becoming a permanent invalid, and his daily and nightly life became increasingly governed by her state. He took her for one last holiday to Rhyl in 1933 before she became, in the Lancashire phrase, bedfast. While he was with her there he thought irresistibly of happier days in the past, sometimes exaggerating time, place, and costume. In one picture which he made on that holiday, *Edward Henry Street, Rhyl* (1933), he included figures in Victorian costume because, as he explained, he had had his happiest days in that period. He used theatrical, outmoded dress in

his paintings on many occasions, as in *Entrance to Christ Church, Salford* (1926).

In his old age Lowry said that in the late 1930s his mother's long final illness nearly drove him to a nervous breakdown, and that mental state is reflected in almost all the important pictures of this period. The watershed is *A Fight* (1935). This basically good-humoured picture has often been cited as the peak of Lowry's Chaplinesque tendency. It is true that Lowry admired Charlie Chaplin very much – not for any deeply intellectual reason, but principally for the comic effect which he had communicated in his music-hall days (which Lowry shared) before the Great War and in the bulk of his earlier, capering films. 'He is just so very *funny*,' said Lowry, and dismissed the invitation to facile weeping. But even *A Fight* is not entirely comic-cuts representation. There is an artistically contrived depth in the mask-like faces of some of the lookers-on – and it is noteworthy that not all wear masks, but that some heads are done with straightforward realism. The total effect suggests a complex, even schizophrenic, mood on the part of the painter.

After *A Fight*, the significant paintings are the deeply pessimistic *Family Group* (1936), and the excruciatingly unforgettable heads of *A Manchester Man* (1936); *Boy with Staring Eyes* and *Self-Portrait* (1938); and *Head of a Man with Red Eyes* (1938). All the commentators have expatiated on the anguish in these heads, and there is no need to say more here. The paintings were done, as Lowry told Monty Bloom, when he was completely worn out with attending to his mother. He could only afford help from a woman in the mornings, and he was responsible for her the rest of the time. 'I was simply letting off steam. My mother was bedfast. I started a big self-portrait. Well, it started as a self-portrait. I thought, "What's the use of it? I don't want it and nobody else will." I turned it into a grotesque head. I'm glad I did it. I like it better than a self-portrait. I seemed to want to make it as grotesque as possible. All the paintings of that period were done under stress and tension and they were all based on myself. In all those heads of the late thirties I was trying to make them as grim as possible. I reflected myself in those pictures.'

It is interesting in this context to consider these paintings of Lowry's

personal agony against the portraits, especially the self-portraits, of Rembrandt, whom Lowry hated. (He actually told Mervyn Levy, 'I detest him.') He gave a number of entirely different reasons for this at various times: 'He's too life-like'; 'He's too matter-of-fact'; but finally, in a sort of self-abnegation of rejection, 'He's too great.' Rembrandt painted over a hundred portraits of himself, often when he was in the depths of despair. It seems to me that there is nothing petty in his portrayal. If he pitied anyone, he pitied Man, with the broadest of understanding sympathy as to what Man can do to himself. Lowry's heads of the late thirties are clinically revealing, and perhaps the more unbearable for that. But the paramount emotion they seem to radiate is self-pity. They do not communicate the *acceptance* which Rembrandt supremely conveys.

During this time of personal stress the country was slowly coming out of the Great Depression with the re-armament and the preparation for war. Lowry had already adopted a sombre social gloom as his own artistic milieu. He was once asked why all the people in the crowd scenes in his pictures, even in the 1950s, wore the old-fashioned clothes, the shawls and the caps and big boots, of a bygone age. He replied: 'That's because my real period was the Depression age of the twenties and thirties. My interest in people is rooted there. I like the shapes of the caps. I like the working-class bowler hats, the big boots and shawls.' But Lowry was only pleasing the questioner, not answering the question. Working-class bowler hats for any but special occasions were extinct by the 1920s. Lowry's true period was the time before the Great War: the period of his *Mill Worker*, shawled and clogged, of 1912; the period of *Hindle Wakes*.

The national Depression did not really affect Lowry, and he also remained untouched by metropolitan sophistication. Occasionally, before his mother's illness restricted his movements, he had accepted invitations from James Fitton to meet him in London, where every Friday evening at the Café Royal Fitton joined the artistic 'lions' of the capital. Lowry had accompanied him and had been quite unmoved: not envious, not particularly impressed. He had no devotion to what he called the 'art world', and this self-containment gave him a certain sovereignty, if no appreciable majesty. He once said reflectively when talking of the strain to which

looking after his mother had subjected him, that perhaps her illness had deprived him of the contacts that might have nourished his career – he did not say his art – at a critical time. He recalled that in 1935 a second dealer from Paris offered him a one-man show there. 'But circumstances at home made it so difficult, I couldn't do it. I was never the man, I could never further my own works. I've never been abroad in my life, never wanted to, really.' Would he have done better to further his worldly career? He rounded on his own suggestion with petulance: 'Perhaps I ought to have gone to London. They don't like northern painters living up here and sending to London. But I wouldn't do it. I would have dropped out first. I have never been dedicated. I have never felt that I was in the company of the saints when I was with artists. They were just ordinary people, like anybody else.'

In 1938 Lowry was working on two major paintings which are perhaps all the greater because they transfer his emotions to external objects instead of reflecting them in a distorting mirror as in the agonised heads discussed earlier. Both depict brooding black churches. One is *St John's Church, Manchester*. The other is *The Black Tower*, a composition in which Lowry again introduced his own figure, the tall, forward-bent commentator, into the foreground. On a certain day while Lowry was working on these two paintings, Alex McNeil Reid, the senior partner of Alex Reid & Lefevre, picture dealers, who ran the Lefevre Gallery, then in King Street, St James's, called in at the firm of James Bourlet & Sons, fine art restorers, framers, and shippers, which had handled Lowry's work for many years and dispatched it to many exhibitions including those at Paris. Reid had called in to see the work of another artist, but it did not please him. While he was there, however, he saw a few pictures of Lowry's lying about. He examined them and liked them and asked to see more. The pictures were brought from the store-room and Reid was convinced he had made a discovery. He had all the paintings sent round to his gallery, where his partner, Macdonald, was similarly enthusiastic. They got in touch with Lowry and arranged to give him a one-man show at the Lefevre Gallery during the next year. The exhibition was held in February 1939 and excited strong critical interest. Lowry sold sixteen pictures, including a

painting taken by the Tate. 'I got more pleasure out of that first show than out of anything else in art,' he said. 'I don't know what I would have done if I had not had it. I think I couldn't have kept going much longer.'

His greatest pleasure was that his mother could enjoy his triumph. 'I had said to her many a time after my father died, "I think I'm a damned fool painting these idiotic pictures when nobody wants them." She said, "You never know, you know." So I kept on doing them.'

Eight months after the exhibition closed, and a month after the Second World War began, Mrs Elizabeth Lowry died, aged eighty-one, in a blacked-out bedroom in the Pendlebury which she had never accepted, though she had lived there for thirty years. She left her son all she had. There were sixteen clocks, including two by Thomas Tompion, and four cabinets of china which she had collected, and her whole estate was valued at £1,076. 17s. 4d.

Now that he no longer had to look after his mother, Lowry felt no sense of relief. He had always been very close to her and his grief was deep. One of the effects of it was that he abandoned all serious reading, though he never lost the desire for music. He cherished his mother's clocks for the nostalgia of their sounding chimes. They were serviced and kept in working order, as a tribute to his mother, but Lowry was not meticulous about regulating them. Consequently, though they all started together after an overhaul, they soon took up their native pace, and never agreed about the time. Chimes would ring out constantly, none of them significant. ('I don't want to know the real time,' said Lowry. But he kept a working clock on the mantel-piece, ten minutes fast to make sure of the bus, and checked it with what he called, after the popular jewellers, his 'H. Samuel' watch, which he threw away and replaced when necessary.) He ignored the porcelain, even lost the keys to the cabinets after a time, and the delicate pieces grew grey with dust behind the glass doors.

Chapter Four

LOWRY was now faced with the task of settling into solitary life in an over-large house which only emphasised his new isolation. It was situated too far from work to be convenient amid the new conditions of wartime transport, and the same disadvantages reduced his contacts with his few friends. The Bennetts, who had been transferred to Widnes, were now moved to Whitehaven in Cumberland. Lowry managed a few visits, but Geoffrey went into the Royal Air Force, Alice had a young child to bring up, rationing severely limited any hospitality, and from 1942 Lowry stayed at home for four years. There was an occasional visit to London to keep in touch with his dealers Reid & Lefevre, who managed to mount two more exhibitions in this period. And Lowry got increasing moral support from Dr H. B. Maitland, a Canadian naval surgeon in the first war who had been Professor of Bacteriology at Manchester University since 1927, a man who was Lowry's earliest important patron, along with Dr H. W. Laing, another Manchester connoisseur, who collected Lowrys long before they were famous, and became the first owner of his most frequently admired work, *Good Friday, Daisy Nook*.

Solitude has strange compulsions. As Lowry said, it put him off reading, which might otherwise have been a solace. Lowry always impressed the new friends he made in later years as being a well-read man. He would cite anecdotes about the Duke of Wellington or some other historical figure that were new to his listeners, and would display a confident familiarity with the byways of the past. He told stories which seemed to give an in-

sight into the personalities of historical characters. 'Bellini,' he would say. 'A great character, but he liked the women, you know. He was in trouble a lot before he was twenty-one. His father told him, "You'll never make a living writing your music." '

Lowry was quite explicit on where he had browsed in the past: 'Charles Dickens and a lot of nineteenth-century writers. Sherlock Holmes, too, and I had a weakness for the detective stories of R. Austin Freeman. But there were others. I used to be passionately attached to the Restoration dramatists. Later on I took to Sheridan, but I think the Restoration dramatists are wonderful. What appeals to me is the beauty of the writing. They give me so much pleasure. They wrote about their times, that certain little world they had, so marvellously and with such style. Particularly Congreve. I went on to Sheridan later, and I read poetry, but it has been the Restoration dramatists who have given me most pleasure. They were artificial, they managed a little world of puppets – pull a string and this one jumps – but they seemed wonderful to me at the time and I think so yet. I think they are very hard to act and it is much better to read them. You can put your own construction on them when you read them. Sheridan, of course, I liked. And latterly Oscar Wilde, who's a very great man. I always think of his enquiry: "Why are you so very nasty with me? I never did you a good turn." There is an awful lot in that, you know.'

There may be an awful lot in it, but Wilde would not have thanked anyone who proclaimed that he had said anything so clumsily phrased. Lowry was never very good on his quotations. The coining of the phrase describing his favourite vice, 'masterly inactivity', he attributed to the Duke of Wellington instead of Sir James Mackintosh. When, not infrequently, he discussed his lonely funeral, he would say, 'A married man lives like a dog but dies like a king; a bachelor lives like a king but dies like a dog: Oscar Wilde said that.' Oscar Wilde said nothing of the sort, but the sentiment – much less pithily expressed, in truth – was adumbrated by Artemus Ward. Discussing religion, Lowry declared, 'I can only go along with Congreve – all I know is that I know nothing.' But this aphorism was ascribed to Socrates by Plato. With regard to his intense interest in the beaten characters of the down-and-outs whom he began to paint when he was seventy,

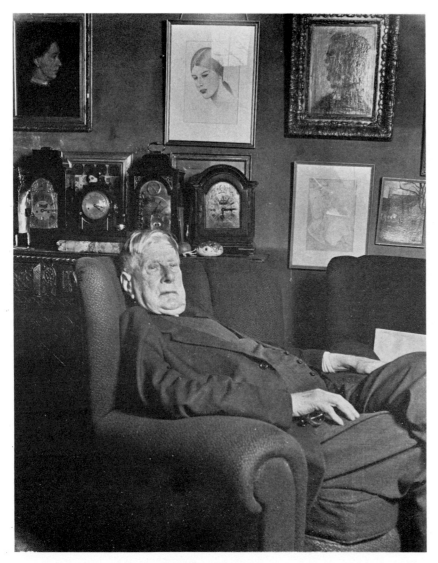

PLATE XXV L. S. Lowry at The Elms, November 1975. Behind him are some of his mother's clocks and his own paintings.
ROGER BIRCH

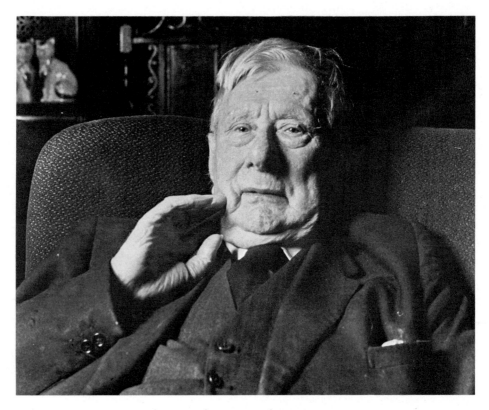

PLATE XXVI L. S. Lowry at home, December 1975.

PLATE XXVII L. S. Lowry, flanked by his portraits of his parents, December 1975.

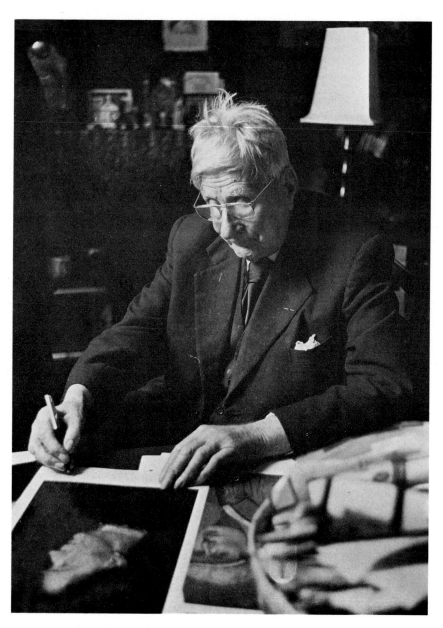

PLATE XXVIII Lowry signing a limited edition set of prints in late 1975.

PLATE XXIX Carol Ann Spiers at her home in Charing, Kent, Summer 1976.
MICHAEL DYER

PLATE XXX Lowry's funeral procession leaving the chapel at Southern Manchester Cemetery, 28 February 1976 – a far cry from the austere and lonely funeral he liked to envision.

MICHAEL DYER

PLATE XXXI Mrs Lowry at the interment of L. S. Lowry.
MICHAEL DYER

PLATE XXXII The Lowry family headstone at the Southern Manchester Cemetery.
GEOFFREY SHRYHANE

he said, 'We are not blameless ourselves, and perhaps in certain circumstances we should have been just the same. As John Stuart Mill said as he passed a man taken for public execution, "There but for the grace of God go I." ' The remark was in fact made by John Bradford, who lived three centuries earlier. It was another example of Lowry's tendency not to insist on the scholarly accuracy of a line, a phrase, or a figure, so long as the general rightness was there. To Edwin Mullins, excusing himself for going back to places he had previously drawn, because of their associations, he said, 'What was that line of Sheridan's? "There's nothing so noble as a man of sentiment." ' But Sheridan in the eighteenth century was not using 'man of sentiment' to mean a man of sentimentality in the modern sense, but a man who expresses noble sentiments, often hypocritically. Joseph Surface, the character to whom the description was applied, was defined by Lady Sneerwell as 'artful, selfish, and malicious – in short, a sentimental knave'.

The Lefevre exhibition of 1939 – it had been billed as 'Paintings of the Midlands by L. S. Lowry', which showed a curious grasp of provincial geography – had come in the nick of time to give his mother before she died some assurance about his talent and possibly his financial future: he had, after all, made over £300, nearly a year's salary, even allowing for the agent's commission. 'It made me feel that I had justified myself to my mother,' he said of this show, though many times afterwards he moaned that his success had come too late for her. He painted a few pictures which were direct tributes to her memory. 'I must have been very sentimental,' he observed to Monty Bloom as they regarded his picture *Judy Lane, Macclesfield* (1940). 'It was just after my mother died. Judy Lane – she tried to push me up it in a perambulator in 1888.' He thought so highly of his painting *The Bedroom* (1940), which depicted the empty bed on which his mother had lain helpless for so many years, that although he donated it to the Salford Art Gallery, he kept it in his house and bequeathed it to Salford all over again when he himself died.

Lowry roamed farther afield in his search for places with happy associations. His picture *Fylde Farm* (1943), which was set in the countryside to which he had made so many quiet painting excursions in the old

days, was the first Lowry to be bought by the Queen, now the Queen Mother.

Just as Lowry had as far as possible ignored the Great War and, as he told an acquaintance, 'didn't even notice there was a Great Slump', he allowed the Second World War to pass over his head as inconspicuously as possible. The Germans obliged, and tossed no more than the average quota of high explosives at him, though en route to Liverpool any odd bomb that could be dropped on Pendlebury was statistically likely to damage an industrial target. The Luftwaffe's only concentrated air bombardment of Manchester was confined to two nights before Christmas, 1940. This was, however, a highly successful attack. The printed lists of the dead fluttered on the boards outside the Town Hall, and the air of the city was thick with dust and ash for days as firemen pulled down into the street with cables the soaring walls of gutted warehouses. Lowry acknowledged the bombardment with a couple of works, *After the Blitz* and *Blitzed Site*, both of 1940; but *Waste Ground* (1940) showed no sign of air raid shelters, and the crowds in *Our Town* (1941) walked without gas masks in front of unsandbagged shops. For a Government-commissioned painting, *Going to Work* (1943), Lowry did concede a pair of barrage balloons. But the women queuing in *Waiting for the Shop to Open* (1943) might have belonged to the Great War.

The Lefevre Gallery gave Lowry his second show in 1943. Under a sort of wartime rationing he had to share the exhibition with Joseph Herman. He made no objection, and privately and publicly promoted Herman's work for years afterwards. His price-tag was still kept at thirty guineas, but he had from the beginning crossed out a clause in the contract which required him to sell through Lefevre exclusively, and he also declined to follow their expressed wish that he should not exhibit at the Royal Academy. It was as a result of this freedom which Lowry had insisted on for himself that he was able to have his first commercial show in Manchester in 1952 under Andras Kalman at the Crane Gallery.

Many of the paintings which Lowry put on show in 1943 were of some years' standing. The most impressive was the poetically desolate *An Island*

(1942), which is now in the Manchester City Art Gallery. But in 1943 Lowry was producing powerful paintings which were not the expected 'industrial scenes with little people'. The people were big, in their desolation dominating their working-class homes as in *Discord* (1943), or the kerbs of their crofts (urban waste ground, often a square of clay or mud between streets), as in *We Two* (1943). It was really nothing new in Lowry's thinking, only a novelty to those who had narrow expectations of his thinking. *Discord* is descended from *The Family* (1936), which itself sprang from a drawing made sixteen years earlier in 1920. *Discord* also looks forward to *Family Group* (1961) and thus provides a bridge over a progression of forty years.

In the winter of 1943 Lowry made the acquaintance of David Carr, an artist twenty-seven years his junior who had studied at the Slade and who from 1944 lived at Starston Hall, Harleston, by the river Waveney in Norfolk. Their relationship quickly ripened. Lowry was always very dependent on friendship, though it must be said that in many respects he used friends for his own needs rather than theirs. One of his intimates has said, 'I never knew where I was with him. He was always glad to see me, but I knew that he was always glad when I went. That did not hold, of course, when it was he who was visiting me, because he would stay for a number of nights.' He would descend on friends for weekends or longer – he certainly seemed able to take ample time off from his Manchester office when he required it – and although he would repay the hospitality he was given, and the succession of quite enormous meals which he devoured, with a considerable quantity of conversation and reminiscence on the subjects which interested him, there was always the impression left on his departure that he had compensated for his own loneliness and in return had offered contact with an artist on his own terms, without particular reference to the habits and preferences of others. His stays were rather like the royal progresses of Queen Elizabeth I round the great families of England – though unlike the Virgin Queen he was not concerned above all with saving himself money thereby. Lowry never maintained, even implicitly, that it was an honour to entertain him. But this almost leech-like behaviour to his friends was the nearest he came to an

unspoken statement that genius, in its egocentricity, demanded a certain
sacrifice from the acolytes.

With David Carr the relationship was different. Lowry did demand
sympathy and indulgence as well as demonstrating rather pathetically the
alternate expectation and pleasure he felt when he was invited as a guest.
But he also visited art exhibitions with Carr, discussed technique, analysed
subject matter, and began to take tours around unfamiliar parts of England
– a considerable adventure for a man who had rarely travelled and knew
little of his own country beyond Lancashire, the West Riding (which he
always regretted he had never painted), and central London.

David Carr was the first *artist* with whom Lowry built any relationship
based on mutual regard, which has to be crudely annotated to mean any
relationship to which Lowry gave anything from his soul. Later he was to
say, 'I have no artist friends save Sheila Fell,' but when that was said David
Carr was dying and Lowry had not been in touch with him for some time.
Before Carr there had been, and there always remained, the painter James
Fitton, an A.R.A. since 1944, a warm Lancashire heart amid the protocol –
for even artists observe and demand protocol – of the London art scene.
Lowry used to say, 'Jim Fitton is the nicest man I know,' but Lowry could
not impose on his first painting companion the dog-like dependence which
he thrust on Carr. Curiously, the age gap between Lowry and Fitton was
fourteen years, between Lowry and Carr twenty-seven years, and between
Lowry and Sheila Fell forty-three years. It was as if Lowry were trying to
stand still while time marched on.

Carr used to meet Lowry in London, and rush him around the galleries
at an exhilarating rate which captivated Lowry, and exhausted him, and
he enjoyed even that stretching of his endurance. He had hardly ever
visited galleries before. To David Carr, Lowry opened out a little to reveal
sectors of his philosophy of painting which were very rarely exposed. At
their first meeting he talked at length about individual problems of what
both were trying to say in their work, what aspect of life they were com-
municating. Lowry said that his own artistic stance, the message he was
conveying, revolved around the arbitrary contrasts of empty scenes and
crowded vistas. An unpopulated street or a desolate building could say

what he wanted as meaningfully as a thronged thoroughfare, and some-
times with more ease when the scurry of people bustling this way and that
might confuse his vision. This is an interesting standpoint, since although
Lowry's deserted vistas and stark black churches made an impact, it was to
be his masterly representation of crowds that earned him the highest
critical respect and appreciation. *Going to the Match* (1953) was greeted with
enthusiasm from its first showing at the Lefevre Gallery in October 1953.
When it was included in the Retrospective Lowry Exhibition at the
Manchester City Art Gallery in June 1959, Eric Newton wrote in the
Manchester Guardian: 'In the fifties . . . with his command of space has
developed a command of movement. The mosaic of figures – the packed
groups of Lowrian mortals – in his earlier pictures have become more
organised. I cannot remember any picture of moving crowds more clearly
stated than in "Going to the Match", 1953, where two streams of spec-
tators cross each other diagonally as though they had been drilled by a
master of choreography.'

Reviewing the same picture at the same time, the anonymous critic of
The Times said that the 'scores of small figures of men, seen almost like
comic insects each advancing through different streams under one com-
pulsion towards the football stands, are most beautifully blended into a
single ever-moving pattern.'

This picture won a prize almost immediately it was shown, which
annoyed Lowry, who maintained that at the age of sixty-six he had now
lost his record of never having won anything. His only consolation was
that he could never be deprived of the cachet of never having passed an
exam. Nevertheless, he felt genuinely honoured when in 1945 Manchester
University proposed to give him an honorary degree as Master of Arts.

By 1945 Lowry was visiting London on a quite casual basis – going up
to Charlotte Street, for instance, for a discussion on his work at the Artists
International Association centre, one of the lively artistic mainsprings
which had been wound up and had chimed in embattled London as a
reminder that war produces beneficent cultural fevers as well as mindless
destruction. He was asked to make a picture for the Artists International
Association exhibition, and rather surprisingly chose to paint *V.E. Day*

(1945), which he finished in three months, very fast time by his contemplative criteria. He went on to compose a picture of the same proportions, 30 × 40 inches: *Good Friday, Daisy Nook* (1946) – the most intricate and, at the time of his death, financially the most highly regarded of all his paintings. Originally this work was bought by Dr Laing.

As soon as he had sent off *V.E. Day*, Lowry prepared for a visit to Carr in Norfolk. It was the first time he had ever been in East Anglia, and Carr gave him a good introduction to it with a tour round the whole area, its varied countryside and shoreline, and the art gallery at Norwich. It was a moment of cascading enthusiasm, and Lowry was now on such artistically intimate terms with Carr that on his return to Pendlebury he sent him some pastels and drawings dating back to 1915 and 1920. Some of the pastels were seascapes, which Carr much admired, but it was Lowry's hope that Carr's interest would be held by this demonstration, even in the crude early beginnings, of his first attempts to depict the industrial scene. He emphasised that from the start his urban landscapes had been done from imagination, and with no obvious false modesty commented on the clumsiness of the drawing. Carr in return sent him his own drawings. Lowry saw a static quality in them that he had already observed in the oil paintings of Carr's that he had seen in Norfolk. He particularly admired Carr's animals, which were very different from his own caricature notations. In the late autumn Carr complained that he could not paint because the short days condemned him to artificial light. Lowry, who was never put off by absence of daylight, but who theoretically conceded the enormous difference between painting out of the mind's eye as against painting from nature, wisely counselled Carr to busy himself with his drawings during the times of artificial light, arguing that thinking things out in pencil would be of invaluable help to the eventual painting.

Lowry was at his most abjectly self-pitying with all his friends on his birthday and at Christmas, when Carr, along with many others, made sure that Lowry knew he was remembered. By a coincidence Carr's birthday was on the day after Lowry's, and during their friendship a son was born to Carr who shared Lowry's birthday. But Lowry always made his birthday an occasion of public gloom, and indeed from his fifty-ninth onwards,

he regularly hazarded the statement that this would be his last. At Christmas Lowry again claimed the right to be melancholy, and wrote reminding all his friends who had children that he himself was deprived of the family revelry and festivity that they were enjoying, and maintaining that at this time of year his friends hated the sight of him even more than usual – 'I have nothing around me but the garden fence' – yet Lowry never spent Christmas alone.

The Pall Mall Property Company was a cosily indulgent firm and was allowing him more time off than the normal company cashier could expect. 'I ought to emphasise,' said the company secretary, Mr T. Mundy, after Lowry's death had discharged the need for secrecy, 'that by the very nature of the business, simply being a property management and investment company, there was a complete absence of the usual commercial pressures, and it was the same unhurried atmosphere which made it seem natural for his employers to be understanding and sympathetic, to the point even of being generous, when demands were made on his time in the post-war period when he was becoming famous.'

Lowry made frequent trips to London. He was hardly a night at home during November 1945. He spent a clear week in Glasgow for his one-man exhibition there in February 1946, and made a return visit before the end of the show, after which he spent some mid-week days in Norfolk. In July he stayed for another stretch in Glasgow, working very hard at some sketches of dock scenes which afterwards fed his paintings – at the February exhibition the Glasgow Corporation had bought *V.E. Day*. In August he made another descent on Norfolk and rather sulkily upbraided Carr for not inviting him on a trip to Ireland later that year. But Lowry himself went in the meantime on an excursion to the Cotswolds. Ostensibly it was to call on his cousin May, Grace Shepherd's sister, who lived in that area. But he made this no more than a duty visit and soon sped off to Bourton-on-the-Water, Burford, and Broadway. He found these places very paintable, admiring the soft warmth of their stone, so different from the sharp dark quality of the stone in the North. He renewed his physical links in Cumberland with Mr and Mrs Bennett, and after an absence of four years found it comparatively easy to mislead this trusting couple

through their own assumption that he did not have or need a mundane job.

Carr, in his dashes round the London galleries with Lowry, made an occasional dive into unexpected territory, and one day he took Lowry to Madame Tussaud's waxworks exhibition. Lowry, coming up to sixty years old, had never been there in his life, and was overcome with delight at the experience. He promptly planned a return visit because he wanted to base a painting on it. While Lowry was in Norfolk he spent some time sketching at Norwich Harbour and Lowestoft, and kept on postponing the pictures he was going to make from these notes. In the rather facile way in which he excused his procrastination to his friends, he declared that they would keep and improve with the preservation.

By October 1946 Lowry had decided to move from 117 Station Road, Pendlebury, because he could manage neither its bulk nor its associations. 'It is the penalty of having too tender a heart!' he explained. At first he retreated only round the corner to 72 Chorley Road, Swinton, which he had decided must be a temporary abode – though it was over a year before he found anything more permanent. In the meantime he used the house as a workshop, and drowned his disgust by dashing off to Berwick-on-Tweed. The Pall Mall Property Company had no interests at all outside Manchester and was beginning to give Lowry his head. While in Glasgow he had made a sombrely effective drawing of the Necropolis. He confessed to having 'a passion for graveyards', and during the next year he was planning a picture to be called *The Murderer's Grave*. But he was spending very little time in his workshop home. After intermittent absences he took a full month away starting in mid-August and a full fortnight off at Christmas; and wherever he went he imposed his pattern of life on his hosts, including a monopoly of their radio sets which they did not always welcome. He was still trying unsuccessfully to change his house, still aiming at that time to continue living in Salford. But the City Council finally requisitioned one that he had set his heart on. Only in August 1948 did he remove fifteen miles east-south-east of Pendlebury across the metropolis to Mottram-in-Longdendale, then in Cheshire, a delightfully named granite-ribbon village of the most apparent inhospitality, which he detested from the start.

Lowry conceded that Mottram was visually grim, but excused his choice with 'I have no scenic sense', a negative quality which, peculiarly for an artist, he consistently claimed: 'I was obliged to leave the house where I had lived. I was advised to: two deaths there, and everything changing, no point in stopping. But I'd nowhere to go. I had a friend in Mottram, used to see quite a bit of him. One day we met in Manchester and he said, "Look here, why don't you come to Mottram, where I live?" I said, "I don't like Mottram." He said, "I know that, but what does it matter in your case? I can find you a house, and it's as good as anywhere else from your point of view." So I went, in 1948, for one year only, and I'm there yet. [He was in the Mottram house when he collapsed before his death, twenty-eight years after he had moved out from Pendlebury.] I hate the place like poison, but I've nowhere else to go.'

It was in the studio he established out of the dining room of his house in this hated village that, working under artificial light, Lowry produced his strongest single sequence of paintings. In two years his work included, in the imaginary, composite industrial landscape genre, *The Pond* (1950), which the Tate Gallery fairly speedily took; as a rival to the *Daisy Nook* composition, *Agricultural Fair, Mottram-in-Longdendale* (1949) – a picture on which Carr commented that he could not tell whether the horses parading in the show ring were dogs or horses (and certainly Stubbs would not have been pleased with them), but Lowry weakly admitted that he could not bring himself to alter them because he 'loved them so much as they were'. During this sequence Lowry produced his *Father and Sons* (1950) in the field of domestic tension; two very striking 'unindustrial' landscapes, *The House on the Moor* and *Heathcliff's House*, both of 1950; and a memorable *Seascape* (1950), which was to start yet another Lowry line of exploration and confound those critics who saw him as an artist confined to the portrayal of the lumpenproletariat. It was also to start a round of municipal art controversy, characterised by the unmercifully heavy wit of councillors, which was extremely unusual in Salford, where Frape's enterprise in securing works for the City Art Gallery was generally approved with enthusiasm. When Salford bought a

Lowry seascape in 1954 for forty guineas, Councillor Mrs Edith Parker (Conservative) declared that out of sheer snobbery the Council had bought 'three lines of paint showing a beach without pebbles, a sea without waves and a sky without clouds, just because it was painted by L. S. Lowry'. 'I cannot say it is a horror comic,' she went on, 'but one or two members of the Art Gallery Committee suggested that someone had forgotten to put it in a frame.' An amendment to reject the picture was defeated. Various citizens and reporters of Salford went into print urging that this 'dirty bit of canvas in a dismal frame' should be 'buried deep in the gallery dungeons', or alternatively permanently exhibited as 'the grossest waste of Public money'. This gross waste was at least up-valued in nine years from forty guineas to £600.

Still in the same painting sequence, and marking his sixth genre originated from his first years at Mottram, were Lowry's highly controversial representations of human affliction, *The Contraption* and *The Cripples*, both of 1949.

The Contraption is less quirky, easier to accept, than *The Cripples*. Lowry's interest in any wheeled vehicle except the motor car has been noted. He was astonished to see in the street one day an invalid car cranked by a hand-wheel, and the unusual sight prompted him to whip out some scrap paper and walk alongside the vehicle sketching it. It was a habit of his which had embarrassed his subjects on other occasions, as when he walked alongside the bearded lady pushing a perambulator in Winchester. In the case of the invalid car there was a similar explosion of bad temper. Although in Lowry's opinion the man had the face of a poet, he had no sweet tones for the artist, and swore at him coarsely. Lowry made a good picture out of his impression of the vehicle and the passenger, and searched in vain for a further sight of it. Though he never saw it again, he was clearly so captivated by the invalid car that he introduced it arbitrarily into later street scenes.

Lowry's intense interest in the physically crippled is less easy to accept, because it is in fact less spontaneous and far less naive. All the 'inside' commentary from his friends regarding his fascination with cripples has started from the challenges that were made to him:

'You don't see people like that.'

'Everything I paint I have seen.'

'You haven't seen cripples like that.'

'I look for cripples whenever I go out.'

'You don't see as many as that.'

'Let's go out now. We'll take a bus ride to Glossop and see how many cripples we can spot . . . Look, there's a man with one arm. Look, there's a hunchback. Oh, look at that beauty! . . .'

That is not an exaggerated dialogue. Lowry was frank in admitting his obsession with the grotesque. He and David Carr once counted 101 cripples on a car journey from Rochdale to Oldham. Lowry himself claimed to have topped this performance by counting 93 cripples on the road between Mottram and Bury. But he modestly excused his high figure by advancing the explanation that, since he was not driving, it was easier for him to keep an eye on both sides of the road whereas previously he had restricted himself to one side only. But his pre-occupation was not confined to achieving a high score. Even when he was painting *The Cripples* he displayed an interest that was more gloating than artistic, as, for instance, when he described an 'operation' which he had performed on one of the figures by endowing him with a wooden leg, or his immoderate amusement at a 'masterstroke' of a suggestion that one of the cripples should have a hook instead of a hand.

It has to be accepted that Lowry had an ultra-sophisticated, or abnormal, addiction for the examination and depiction of human beings handicapped either physically or mentally. He always had little stories or judgements about the characters in his pictures, and one of his remarks when he was commenting on a figure deliberately and painfully painted as an idiot was 'That lad will never be Prime Minister, will he?' Sentimental as far as his own life and his family losses were concerned, Lowry was hard in his dissection of outsiders. He had a tendency to deprive himself of affection for anyone, except the girls whose patron he became, and eventually to be interested in individuals in proportion to their grotesqueness: 'I'm much more interested in deformed people because . . . oh, because they look so *comic*.' On the other hand, however, he refused to paint an identifiable

cripple who used to sit on a trolley outside Alick Leggat's factory, '*because he will think I am laughing at him*'.

Within a month of Lowry's removal to Mottram, David Carr came up for a guided tour of Lancashire. Lowry showed him all the places which had been the basis of his paintings, and also the not inconsiderable public art collections. But Carr, in his eagerness to see, taught Lowry to look, and showed him new things in his own backyard. Lowry confessed that he had learnt more about Rochdale than he had ever known before. Carr, with his charm and energy, was always good for Lowry, whether he was rushing him off his feet in a speedy progress through the Bond Street galleries, or taking him to Norwich and planting him in front of the Munnings pictures in the gallery there. Lowry particularly missed this personal contact when illness struck him. He was depressed and lethargic even when he was not identifiably sick, through the winter of 1949–50. He even submitted to the preparation of a psychiatric report. He realised that Mottram, and The Elms in particular, was an unsuitable domicile, and made several attempts to leave, half-regretting his refusal to buy a delapidated house at Levenshulme, and just missing renting another house near Manchester. His intentions were clearly to move back into the suburbs – but now the suburbs of Manchester, not Salford – rather than endure the rheumatic rural squalor of The Elms, Stalybridge Road, Mottram-in-Longdendale.

In 1952 Maurice Collis published his book, *The Discovery of L. S. Lowry* (dated 1951). Apart from twenty well-chosen representative reproductions, half of the text was devoted to a vigorous attack on past critics of Lowry who had dismissed him as a primitive, or merely as an Englishman. The other half detailed a short tour with Lowry of the Salford he had portrayed. There was little emphasis on the variety of his work. This was the book which set down that statement now graven on the heart of every art student: 'My whole happiness and unhappiness were that my view was like nobody else's. Had it been like, I should not have been lonely; but had I not been lonely, I should not have seen what I did.'

Collis certainly stimulated interest in Lowry, though Alex Reid & Lefevre, who had sponsored his book, did not follow the obvious course and increase Lowry's price-tags. The art critics of *The Times* had been

most seriously lambasted in Collis' warming-up excoriation, and the *Times Literary Supplement* did its rather feeble best to retaliate: 'The text of this book is perhaps even more embarrassing for the artist than for the casual reader, for Mr Lowry is an unassuming painter . . . Why has such a vulgar and disagreeable volume been found appropriate to the occasion'?

Meanwhile Lowry, who never had any objection to people talking about him so long as he could lay down the fences confining their discussion, slipped quietly out of the Pall Mall Property Company and, now sixty-five old, accepted his due pension, which he later waived. At last he no longer had to secure special indulgence to go away and sketch.

Lowry was commissioned by the Ministry of Works to paint a picture of the Coronation Procession of Queen Elizabeth II. He was given a good seat in a stand opposite Buckingham Palace and told to be there at six o'clock in the morning. He arrived much later with a large packet of sandwiches, which he found to be superfluous since a buffet, a bar, and all the conveniences had been installed. He loved the minor accidents and incidents that could be expected from a large crowd on the spree, especially the performance of a trespasser at the top of the scaffolding of his stand who defied the police to fetch him down. But he decided that this was not the sort of thing that the authorities were paying him to depict.

He made no sketches, and went away after the procession left Buckingham Palace for Westminster Abbey: a lucky decision since it poured with rain soon afterwards. He went back next day to check the view again from the deserted stand, and eventually produced an elevation of Buckingham Palace with a Lowrian version of the royal coach and the mounted escorts. He painted the picture quickly and was off to the Edinburgh Festival with Carr. While he was there he talked to the musicians.

Lowry had a genuine regard for music. 'Music has saved me,' he used to say, and the implication was that it had saved his balance if not his sanity. Bellini was his favourite by the time he was old. He thought the last act of *Norma* was the most affecting music in the world. By 'affecting' he meant something transcendental, not merely emotional or sentimental. Paintings did not 'affect' him. Music did. His almost religious respect for Bach was because 'it gets me to the other side'. It is interesting therefore to record

that Lowry also displayed a very marked attachment to those rather cloy-
ing radio programmes in which Sandy MacPherson performed on the
theatre organ – 'Twilight Hour' and 'The Chapel in the Valley'. Lowry
used to complain bitterly that when he was visiting for a weekend, some
of his hosts refused point-blank to turn on the radio to receive Sandy
MacPherson.

In 1954 the secretary of the Royal Academy approached L. S. Lowry
and asked if he would consider being nominated for election as an Associ-
ate of the Academy. Lowry sincerely questioned whether he was worthy
of the honour. He was certainly not yet very well known to the establish-
ment. At the election, Harold and Laura Knight took their usual counsel
and asked James Fitton whom they should vote for. Fitton assured them
that it should be Lowry. The Knights were somewhat appalled when they
saw the work of the man they had put in. They might have been mollified
if they had known that Lowry, who was always independent in his judge-
ment and, unlike most artists, preferred to buy the work of other painters
rather than live with an excess of his own, had a Laura Knight hanging in
his sitting room.

There was a responsive bubble of publicity after the election. The
Manchester Guardian, which had given unsycophantic support to Lowry for
a third of a century, commented: 'Mr Lowry has lived all his hard life
among us, has found here his sufficient beauty, and has opened our eyes to
the harsh wry poetry of the Lancashire industrial landscape. It has been a
hard journey . . . It was twenty or thirty years before he could get many
others to begin to see something of what he was seeing . . . Things seen
that moved others to repulsion, or anger, or pity, or mere despair have
moved him to a kind of compassionate affection . . . The more credit,
then, to the Academy, to recognise a fine painter in one who has not, after
all, been for so very long held in honour in his own country.'

Lowry's only reaction was, for no clear reason at all, to change the myth
regarding his conversion to the 'harsh wry poetry' of the industrial land-
scape. It was only three years since Maurice Collis had beautifully enshrined
the moment in the jewelled casket: 'I was with a man, and he said, look, and
there I saw it.' But now Lowry was maintaining, in interview after inter-

view, a far less inspirational, Monday-morning version: 'I started painting Salford by accident. I was at the Manchester School of Art – and I wasn't doing very well. One day I missed my train to school, and I had to wait a bit. So I walked up and down outside the station. There was a spinning mill. I got a pad and started drawing it. And then, when I'd done a few more drawings, I painted that mill. And that's how it all started. I decided to give up the art school, and paint what I wanted to paint.'

It had all happened fifty years before, and perhaps Lowry could be excused for feeling inside the lottery bag for the ball with the best explanation: he did have that sense of mischief. But, delighting in the teasing, he left a new escape open by a further ambiguous pronouncement. In an interview with Margaret Roberts, a responsible writer on the arts, he said: 'Would I starve for my art? Frankly, no. But I see no reason why one should. There are plenty of jobs with little responsibility which leave time for art. The strain of starving is not conducive to art.'

No one could say that he had left no indication of his attitude, and of his own successful cultivation of a 'job with little responsibility'. The directors and staff of the Pall Mall Property Company loyally made no comment, and the artist painted an industrial landscape by L. S. Lowry, A.R.A., to hang in their board room.

Lowry was now consolidating separate outposts of friendship in many spheres. But he demonstrated his peculiar insistence on contriving, wherever possible, that his friends should not meet, lest they should compare notes. On one tour in Cumberland Lowry took David Carr right past the door of Mr and Mrs Bennett, without mentioning that his oldest friends lived there.

Chapter Five

IN THE dozen years ending with his eightieth birthday a triple revolutionary change affected the life of L. S. Lowry. He became involved with what his friends – hitherto, except for his angel Margo Ingham, who had exhibited him consistently from the first time she had opened a gallery, all male – described as 'the Lowry Women'. He became rich. And he altered both the style and the subject matter of his paintings very radically, and by no means obviously for the worse – a feat which in itself was amazing for a man of his age.

Of the three upheavals the most sudden was the dramatic expansion of Lowry's personal fortune. This made no difference to his life-style at all except that during the 1960s, when his prosperity was becoming apparent, he began to acquire, sometimes at considerable expense, the century-old series of girls' portraits by Dante Gabriel Rossetti which were clustered in Lowry's house when he died. In Rossetti's depiction of their faces Lowry fancied that he identified an 'uninhibited passion' on the part of the artist. 'There's something about Rossetti's women,' he said disarmingly. 'They're so unpleasant. I think they were probably ladies of the town. They fascinate me. They are very unpleasant but very fascinating.'

What is most remarkable about this series of changes is that they occurred when Lowry was between sixty-eight and eighty years old: that is, between his election as an Associate of the Royal Academy in 1955 and the end of the provincial tour of his retrospective exhibition, originally mounted at the Tate, and the Post Office's issue of a Lowry postage stamp in 1967.

Lowry had always been generous with young artists, not by teaching his own technical tricks, which he avoided, but by encouraging them when it was heart and confidence they needed, and by recommending them when their work stood up strongly enough to be bought. Before the period covered by this chapter he had 'adopted' in this way a young female art student who lived near him. She got married, moved to the South of England, and felt that she had let Lowry down by moving out of his orbit and into the nesh South.

In November 1955 a twenty-four-year-old Cumberland artist, Sheila Fell, had her first one-man show at the Beaux Arts Gallery in London. Lowry went to the exhibition, liked what he saw, bought two pictures, and asked if he could meet the artist. A meeting was arranged and in the same summer of 1956 Lowry and Sheila Fell went to stay with Miss Fell's parents at Aspatria, Cumberland. This excursion was so successful that it became an annual holiday. When Lowry came to London, which Miss Fell had made her base, they went together to the theatre, opera, and ballet. Sheila Fell's career prospered at a very fast rate compared with Lowry's. She was made an A.R.A. at the age of thirty-seven and a full Academician when she was forty-two, only a dozen years after Lowry's promotion at the age of seventy-five. Lowry praised her work constantly, in private conversation and in influential recommendation: 'If you ask me seriously what artist I like best of those practising today, I would say Sheila Fell. And that's a considered statement. She's a very sincere artist. There is a poetic quality about her landscapes that attracts me very much.' As a very private person divorced from the London rat-race, Lowry made Sheila Fell his only close link with professional art circles: 'The art world goes its own way and I go mine. I have no artist friends save Sheila Fell, whom I know better than anyone else.' Altogether Lowry bought fifteen paintings by Sheila Fell, which were part of his estate when he died.

In the year that Lowry met Sheila Fell he began to paint Ann Hilder. This was no sudden acquaintance. Miss Hilder's family was well known to Lowry. Her father was a man of some means who lived at Pontefract. Lowry greatly admired him, and he and the Hilders used to exchange visits. Ann Hilder became a ballet dancer, but eventually gave up that

career to do charitable work. She was a girl of considerable culture and did much to deepen Lowry's appreciation of music. Lowry began to paint a whole series of portraits of her when she was in her late twenties, and continued to paint her for a number of years. Pictures of her were very obvious in his living room, and the amateur psycho-analysts construed them into representations of an instant dream-woman combining the idealised qualities of any female who had affected Lowry, from his mother onwards. The fact is that the way Ann Hilder 'came out' on the canvas is the way Lowry saw her. Moreover, it had been Ann who requested a portrait in the first place – although she did not realise that so many would result, and she was not particularly struck by the likeness: 'She asked me, would I do her? I said no at first, but I'd no chance and I had to do it. No chance at all. She was a very determined young lady. I painted her picture and she said, "Do I look like that?" I said, "I'm afraid you do to me." Then I got interested. I did quite a lot. Couldn't do her now. She's gone.' Ann Hilder, though she came at intervals to visit Lowry, moved away from the North and virtually out of his life.

Carol Ann Lowry, L. S. Lowry's heiress, came into his life at the same period that he was cultivating Sheila Fell and Ann Hilder, and, with Miss Fell, was a feature of the rest of his life. As far as Lowry's friends were concerned she was the most mysterious of the Lowry Women. This was entirely Lowry's doing, for he told different stories about her to different people. Lowry's oldest friends seem to have been given a version which Carol Lowry, now Mrs John Spiers, has since denied. It was not true, of course, that Carol was 'one of his women' when the relationship started: that position was held by her mother, Mrs Martha Lowry, formerly a weaver called Mattie Smith, who married a cotton-spinning operative named William Lowry in Heywood, between Rochdale and Bury – the ambience is pure *Hindle Wakes* – and whose daughter Carol Ann Lowry was born on 24 April 1944. Martha and William Lowry separated in 1956. Martha Lowry determined to make a bid for the sympathy of L. S. Lowry, her husband's name-sake. As L. S. Lowry generally told the story, it happened like this:

One night there was a knock on the door of The Elms. Lowry opened

the door and saw a very small, tough woman with a little girl of twelve or thirteen. 'Our name is Lowry,' said the woman. 'We think we're related.' The effect was comic because Martha Lowry tends to play everything consistently for comedy. It is her great delight that she is always being compared to the Lancashire comedienne Hylda Baker, and indeed her looks, gestures, accent, and size – both ladies seem well under five feet tall – accentuate this similarity. Lowry gazed with some uncertainty at the pair.

'Well, if you're related, you'd better come in.'

Once settled in the sitting room, Mrs Lowry explained that she and her husband had separated, it would probably mean that Carol would have to be taken away from her convent school, Carol had some aptitude for art, possibly it was hereditary since they might be related, and would Mr Lowry consider helping them?

Lowry took to the little girl, did see some artistic talent in her, did guide her through school and afterwards through a number of art schools. He helped the girl and her mother financially and gave them some of his pictures. And even after Carol had left home he still went to the flat in Rochdale which she and her mother occupied. He generally went on a Sunday, when his other friends did not want to see him, and Mrs Lowry cooked him a succulent Sunday dinner and fussed over him. As for their being relations, Lowry said he did not bother about it. (He had, in fact, made rigorous enquiries and established that they were not.) 'If they like to think they are relations, why shouldn't they?' he commented. Both Martha and Carol called him 'Uncle Lowry', and he called Carol 'child'. He had a perfectly good, though different, relationship with each of them. He did tend to indulge Carol as one would a favoured child. He thought that he had done well, and so had Mrs Lowry, whom he considered a very good mother. Without her, he said, Carol might have finished up in a mill at the age of fourteen and have been dead by the time she was twenty. He did not think that she was a strong girl, and she would not have been able to stand up to mill life as her mother had done.

Knowing after some years that his naive welcome to the pair on the doorstep seemed somewhat simple in the telling, Lowry gradually, through practice, changed the mood of the tale until it became more

sophisticated. He would begin his story more knowingly, after some enquiry about who Carol Ann really was: 'Oh, she's some distant relation of mine.' Then a dark mutter: 'She's not really, you know.' Then, in normal explanation: 'One day I was sitting here and a lady and a little girl knocked at the door and said, "Our name is Lowry, we're relations of yours." I don't think they were, you know . . .'

To one single friend, however, Lowry told a different story, far more romantic in a fairy-tale way, and perhaps more embarrassing to Lowry if he wanted to maintain the reputation of a practical, cynical man. It went in this fashion:

Out of the blue he got a letter which, against his normal inclination, he opened. But as soon as he read it his first reaction was to toss it in the waste-paper basket as the work of yet another cadger. It had been written by Carol, probably at the dictation of her mother, and it said that they might be relations and they were in a bad way because of their family difficulties, and she was very interested in art. For some reason he did not throw the letter away, but put it in his pocket as useful scrap paper on which he could make one of the sketches he jotted down when he was out. But he did not forget the story it told. One day in Manchester he had had a miserable day and he decided to go back early to Mottram. He was waiting for his bus, but the bus that pulled up first at the station was marked with its destination as Heywood, the place from which the letter had come. On an impulse he got into the bus and he pulled the letter out of his pocket in order to verify the address. He found the house and called at it. Carol Ann opened the door. She said with some attractive spirit that her mother was out and he was not to come in, but he could call back later. So he went and found a place where he could have a cup of tea, and then returned to the house. Mrs Lowry was in, and she told him about the separation from her husband and the prospect that Carol might have to be taken away from convent school, and Carol had some artistic talent, and she thought they might be related. He was attracted to the little girl and took her up. All his friends were always telling him that he didn't know what living was until he had children to plague and delight him, and he welcomed this chance of taking over a family. He thought she had some artistic talent,

and he sent her to the art school at Hornsey, after preliminary lessons with Leo Solomon, his friend who was Principal of the Rochdale School of Art. She did not do too well at Hornsey and left, but afterwards she went to Swansea Art School, obtained a diploma, and finally got a job teaching art in a girls' secondary school.

This is a different story from the tale which he used to tell on most occasions. The only person to confirm or deny it should be Carol. On 5 June 1976 Mrs John Spiers, formerly Miss Carol Ann Lowry, said: 'Mother persuaded me to write to Mr Lowry when I was thirteen. He called suddenly at our home one Sunday and then came every week after that. I didn't see much of him in the last two years before he died. I called him "uncle" and he called me "child", but I don't think we were related. He gave me pictures I particularly liked and three of them are among his very best.'

Lowry's second revolutionary leap, his change of style in painting, came about through a development in his own thinking, but became accepted through a most fortuitous process. But for the intervention of a man who was then a complete novice in art appreciation, the paintings which initiated this strong new style would have finished on the bonfire which was being prepared for them, and Lowry – a man who at the age of seventy needed a degree of artistic encouragement – would have abandoned his new mission.

The man who, through sheer chance, intervened was Mr Monty Bloom. Born in the Welsh valleys, he gave up his intended career as a doctor in 1939 in order to learn to fly with the Royal Air Force. Later he settled in Manchester as a business man, by chance concerned with property. In 1957 he came home from a hard day and settled in his armchair at about a quarter to nine in the evening. He wanted to see the nine o'clock news, and thinking he might fall asleep before it started, he switched on the television early, hoping that he would be pulled out of a doze by the chimes of Big Ben. It happened that the preceding programme was the B.B.C. film on Lowry which had been made by John Read. Because Bloom did *not* go to sleep, he gradually became the most important private collector of Lowry's work. His account is vivid:

'It was so accidental. I got the last ten minutes of that film. For some reason or other, these were the first paintings that had ever moved me. I was born in an industrial area, which probably had something to do with it. I wanted one. I thought, "We've never had a painting on the wall, we must get one of these." I started making enquiries and it took about a year, I suppose because I didn't know my way about. A man who said he was always seeing Lowry never saw him for six months. I was introduced to Ted Frape, the Director of the Salford Art Gallery, and he said, "I go up and see Lowry every three weeks. I'll see if he's got a good one of the sort you want."

'Later Frape said, "I've got my eye on one he's doing, and I think it's the sort of thing you ought to have." Then I was at an Arts Council Exhibition in Manchester one day, and by chance Lowry was there and I was introduced to him. He said, "Ah! Mr Bloom. I've got a painting for you." I said I would like to see it so I arranged to drive him home later. I went to see this picture, but scattered all around the studio were small paintings, little single figures. I said, "Those are interesting. I think I like these better than the big ones. I prefer them to the mill scenes."

'He pricked up his ears at that. No one had ever before said they liked them, and he was painting them but getting no response. He put about twelve of them on his easel and asked which I liked best. I picked six and he said, "Those are my favourites, too." I said, "Do you want to sell them?" He said, "Do you really want to buy them?" I asked how much he wanted for them. He said, "Would ninety pounds be all right – for the six?" They were the first ones he sold.

'He told me he had sent some of them up to London but they had been returned, with a query as to whether they were finished. He said that maybe these figures were sordid, but that was what he wanted in his painting at that moment. He didn't want pretty pictures, he wanted life, humanity. He felt that he had not been able to reach it until that stage in his life, and that now he had reached it, it was important.

'He said: "I was just saying to Mrs Swindells [his housekeeper], 'Here I am painting my best pictures and no one wants to buy them. I don't know what's going to happen to them when I'm gone. I'm going to take

them all out into the garden and we'll have a bonfire.' " '

Monty Bloom concentrated on buying these single figures almost to the distress of his family. He ended by bringing them home in the boot of his car and not unloading them until the family was asleep. Eventually he had some sixty of them, hanging all over his house.

'The first time they reached the public was when Constantine, then the Assistant Director of the Graves Art Gallery in Sheffield, rang me up in 1962 and said they were mounting a retrospective exhibition on Lowry, and he had heard that I had some of the later works. "I've never seen them," he said. "If you're willing, we'd like to borrow two or three. May I come over and see them?" He came and saw sixty – and he borrowed forty-eight. It was that exhibition at Sheffield in 1962 that really opened the eyes of the critics as to what Lowry was up to.'

The single figures referred to here are the sombre studies exemplified by *Woman with a Beard* (1957), and *Man Drinking Water* (1962). These were painted after direct observation by Lowry. He sat opposite the bearded woman in the first-class carriage of a train from Newport to Paddington, and sketched her, and tried to draw her out on the state of mind she was in. He observed the derelict drinking water in the public lavatory in Piccadilly Gardens, Manchester, where the man slunk in as if he were committing a crime and, when he thought he was not being watched, pulled a tin from under his coat and filled it at the tap.

In the same vein Lowry produced small groups like *The Interrogation* (1962). 'I saw that,' he afterwards said. 'I was passing along a bit of a square with a lamp in it, and I heard a crash of glass. A lady ran out and she saw three kids there. The lady guessed, but guessed wrong, and got hold of the wrong boy. The girl was ashamed for the boy who had really done it. But he was naturally laughing his head off.' Another extremely powerful small group is *The Two Brothers* (1960). This, by mischance, was not shown in the great Royal Academy posthumous exhibition, although Lowry had told Alick Leggat that it was his favourite picture. 'It is absolutely symbolic of life,' he said. 'There are those two fellows, they could be brother salesmen, they could be calling door to door collecting insurance. There are two figures in the back whom *I don't mean* to be policemen but

who could easily be taken for such. There's the church at the back, the two little kids there, and these two poor devils going about their business. Now *that's* the industrial scene, too.'

As far as the large mill scenes were concerned, Lowry was saying by the mid-sixties: 'I have done the industrial scene. Finished with it. People still want me to do mill scenes with little people. Well, they must do without the little people.'

In another phase Lowry produced canvases with no figures on them at all – the seascapes, completely void of humanity or machinery. 'The sea is a great attraction to me,' said Lowry. 'The sea with nothing. Empty. An immense thing to see.' He became increasingly occupied with sea pictures and beach scenes after he had discovered a haven at the Seaburn Hotel in Sunderland, where he used to go to stay for weeks at a time towards the end of his life. But he had had a strong connection with the North-East since the Stone Gallery at Newcastle, directed by Ronald Marshall, ran a very successful follow-up, in 1964, to the Graves Gallery's revelation of Lowry's late pictures concerned with the mystery and suffering of the individual. Lowry eventually became a director of the Stone Gallery and a great friend of Mr and Mrs Marshall.

With Monty Bloom, who also became a great personal friend, he explored Wales, which he had seen only once previously with David Carr on a solitary tour. Twice a year for six years he visited the valleys, and produced striking (and, for Lowry, very large) canvases of Bargoed, Ebbw Vale, and the memorable *Rhondda Village, South Wales* (1964).

In 1962 Lowry was elected a full Academician at Burlington House. That particular elevation made no difference to the prices which his work was fetching, which was only due to the interest of the public, and the speculations of the investors. But his 1967 Academy pictures, three small landscapes, were priced and sold at £750 each, and for a large work he could ask £4,000. 'It has all come too late,' he moaned – and left theatre or concert tickets with the secretary of the Royal Academy in the hope that some student from the Academy Schools might care to sit with him that evening.

Before Harold Wilson went out of office in 1970 he offered Lowry a

knighthood. Lowry turned it down with dignity, asking Alick Leggat to help him draft his letter of reply, in which he said that worldly honours meant little to him, and he was content to be judged by the verdict of posterity. A similar courteous letter went to Edward Heath in the early seventies, declining the appointment of Companion of Honour.

Lowry eased off his painting and settled down, not without moaning, to the company of his friends, on whom he was increasingly dependent, and the scroungers who could never keep away from his door for long. People who looked like art students would call with the tale that they had saved fifty pounds and if he could only spare something for them to buy . . . They would produce the money – sometimes from a suspiciously large wad. Lowry would politely refuse to sell them anything. He recognised them as runners from the dealers, who had been told to get for fifty pounds something that would be sold next day for two hundred. Crude dealers, taking him for a simpleton, would drive up with an empty van and expect to be able to cajole him into parting with the contents of the house. He seemed very simple but he knew all the tricks. A print publisher made an agreement with him to sign 850 prints for a fee. The going rate was then four pounds a signature. The dealer handed over a cheque – which Lowry cannily requested in advance – for a lower figure. Lowry said nothing, but set himself to signing the prints. The business person looked over his shoulder and observed that the signatures were reading L. S. LOW. There was an immediate query. 'But that's not your signature, Mr Lowry!' 'No,' said Lowry. 'It's a small signature for a small cheque.' The cheque was immediately amended to the going rate – and Lowry signed his full name.

He was mischievous, even to the point of denying the authenticity of his own early drawings when it amused him to confound a speculator who had bought late at a high price in the market. He was mischievous even in his meanness. On one occasion when Mervyn Levy had asked him and Alick Leggat to lunch with himself and Andras Kalman, Lowry had previously had a keen discussion on who should pay the bill for lunch. (Lowry never paid for his lunch except with Leggat, his most candid and supportive friend, who insisted on turn and turn about.) Leggat said, 'I'm sure Mervyn Levy will pay; he's a professional journalist; he will get his

exes for it.' Leggat recalled later: 'The bill came. Lowry gave me a kick under the table and then a nudge. Nothing happened, and he edged it gently towards Mervyn Levy. Eventually Levy picked it up. I felt a bit sorry for him and I said, "Come on, I'll toss you for that." But Levy lost. Lowry was delighted.'

The most serious example of Lowry's sense of mischief was in the matter of his will. There were various contestants for his fortune. The Whitworth Art Gallery, attached to the University of Manchester, wanted to reproduce Lowry's living room and downstairs studio in the gallery, and asked for the bequest of the ground-floor contents. Since Lowry particularly wanted, for sentimental reasons, an honoured resting place for his mother's piano, he was inclined to agree. He changed his mind when he realised that he was expected to pass over at the same time the pictures in his home, which included, among many of greater market value, his collection of Rossettis. With more diplomacy exerted he might well have done even this, if he had been given assurances that the Rossettis would not be consigned to a cellar. In the end he announced, 'I'll leave the Whitworth my walking-sticks.' But he did not even do that. In the considerable lethargy of his age he omitted to change his will, though he assured many of his friends and even his housekeeper that he had done so, and had completely reversed his former intentions. The eventual losers were the Royal Academy, to which Lowry was most strongly attached, though in his shyness he never attended a banquet there, but regularly, in a nineteenth-century manner, paid courtesy calls on the secretary. Lowry had enthusiastically discussed with Alick Leggat his proposal to make over his estate to the Royal Academy so that all the proceeds could be devoted to the foundation of scholarships for deserving artists – both students and mature painters. He did not do it. But he mischieviously knew that he had not done it. He told James Fitton, 'I haven't made a proper will, and I am going to have fun after I'm dead, looking down to see all the fighting going on.' But his will of 1970, dated before the marriage of Carol Lowry, was perfectly proper, and probate of the £300,000 estate was promptly granted.

In age Lowry was also increasingly cantankerous. He hated 'working for Healey' but he always paid his taxes with scrupulous honesty: he

would never accept the multiple thousand-pound notes sometimes offered him in cash for his later work. Yet he never bothered about what his incoming mail might bring him. Once Alick Leggat insisted on taking him through the high pile of unheeded mail in the china bowl on his table, and extracted in all sixteen hundred pounds in cheques.

Even when wealth came to him, in his old age, Lowry's way of life remained spartan. He had few personal possessions, and said that he could not afford a television set, particularly the licence, though in fact his current account at the bank often stood at £50,000. He had one suit for visiting, and one for working, which was much stained with food and the remains of the last year's meals. When asked what he did with his old suits, he replied dryly, 'I wear them.'

He was profoundly interested in *people*. He had a strong sympathy for those who had lost what he called the Battle of Life. When he concentrated on his last, tragi-comic single figures he said: 'I feel very strongly about them, and I know there is some great tragedy that has occurred in their lives and has arisen because they were not proofed to stand up against such calamity. I feel more strongly about these people than I did about my vision of the industrial scene.'

He was profoundly thankful for genuine appreciation. He did not like to see his pictures used as speculators' commodities – apart from his resentment at the impression among the general public that he was getting some commission on a five-figure auction price for a picture he had painted forty years before. At his Retrospective Exhibition at the Tate he met a lady who told him that she had fourteen of his pictures. 'They will never come into the market,' she said. 'I've enjoyed them and if anything happens to me they will go to relatives who will enjoy them.' Lowry was very satisfied with that encounter, though he added, not entirely inconsequentially, 'Of course, she bought them at the right time.' The fact which really pleased him was that she had bought them because she liked them.

Lowry was tired at the end, longing for what he called the Big Sleep. It came to him at the age of eighty-eight on 23 February 1976, as a result of a stroke followed by pneumonia. He did go gentle into that good night, passing with the trace of a smile. He had painted about eight hundred

pictures in his life, and they were all remarkably individual and particular to Lowry. He looked, he saw, and he never excused himself for what he had seen. In spite of an arduous and mundane life he was an artist for every moment of it. When he was asked, 'What are you doing when you're not painting?' his answer used to be, 'Thinking about painting.'

Select Bibliography

BARBER, NOËL. *Conversations with Painters.* London, 1964.

COLLIS, MAURICE. *The Discovery of L. S. Lowry.* London, 1951

LEVY, MERVYN. *L. S. Lowry.* 'Painters of Today' series. London, 1961.
'Lowry and the Lonely Ones', *Studio*, March 1963. London.
The Drawings of L. S. Lowry. London, 1963, 1973.
The Paintings of L. S. Lowry: Oils and Watercolours. London, 1975.
Selected Paintings of L. S. Lowry: Oils and Watercolours. London, 1976.
The Drawings of L. S. Lowry: Public and Private. London, 1976.
L. S. Lowry R. A. 1887-1976: Memorial Exhibition. (Royal Academy).
London, 1976.

MULLINS, EDWIN. *L. S. Lowry: Retrospective Exhibition* (Tate Gallery).
London, 1966.

ROBERTS, ROBERT. *The Classic Slum: Salford Life in the First Quarter of the Century.* Manchester, 1971.

ROTHENSTEIN, SIR JOHN. *Modern English Painters.* London, 1956.

A NOTE ON THE TYPEFACE

*This book was composed on the Monotype in Bembo, Series 270, a face
originally cut by Francesco Griffo for the great Venetian printer Aldus
Manutius who first used it for a short Latin tract, de Aetna, written by
Cardinal Bembo and published in 1495. It is the earliest and undoubtedly
the most beautiful of all old face designs in the history of typography and
its profound influence throughout Europe over the succeeding centuries cannot
be over-emphasised. It was copied by Claude Garamond in Paris, and by
Robert Granjon for Christophe Plantin and others. It took deep root in
the Low Countries and was re-cut by van Dijck; and it was this version
that William Caslon took as his model when the English typefounding
trade was revived in the 18th century. The italic for Bembo was based on
a chancery face of the great writing-master Giovanni Tagliente (1524)
and it is a perfect match for the roman. The re-cutting undertaken by the
Monotype Corporation dates from 1929.*